Figure Drawing
for Kids

FIGURE DRAWING
for kids

A Step-by-Step Guide to Drawing People

Angela Rizza

ROCKRIDGE
PRESS

Interior and Cover Designer: Jami Spittler
Art Producer: Janice Akerman
Editor: Natasha Yglesias
Production Manager: Oriana Siska
Production Editor: Melissa Edeburn

Interior Photography: p. 66: Lucas Ottone/Stocksy.com; p. 67: VISUALSPECTRUM/Stocksy.com; p. 68: ZOA PHOTO/Stocksy.com; p. 69: sasar/istock.com; p. 70: MPH Photos/Shutterstock.com; p. 71: William87/istock.

Illustrations © Angela Rizza, 2019

ISBN: Print 978-1-64152-771-2 | Ebook 978-1-64611-812-0

R0

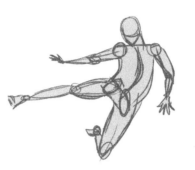

This book is dedicated to my grandparents, John and Martha Leone, who bought me my first drawing desks and art supplies and who inspired me to pursue art and always work on getting better.

CONTENTS

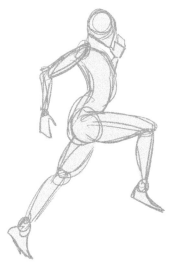

**We learn from failure,
not from success!**

-Bram Stoker

INTRODUCTION

Hello, budding artists! When I was your age, I used to doodle from how-to-draw books. With time and practice (and those helpful books), I grew up to be an illustrator. If you want to be an artist when you grow up, or if you're just looking for something fun and creative to do, this book can help.

It's easy to feel overwhelmed by illustrations in books and think you can't draw anything similar. I don't want you feeling that way, so I've broken the drawings in this book into simple steps, with plenty of verbal and visual tips. And don't worry, nothing you draw has to be perfect! Your first few drawings may not look exactly as you intended, but remember that nobody learns without making mistakes, trying new things, and leaping outside of their comfort zone.

I've given you a range of fun characters to draw. I want you to learn how to draw the human form, but also humanity. Thinking about your subjects as real people will make your art beautiful. Some of the figures in the book are inspired by my friends and family. Maybe a few resemble *your* friends or people you see around you. We deserve to truly see ourselves and others in our art, and I hope this book serves that goal.

Go at your own pace. If you feel like redoing an activity before moving on to the next, that's totally fine. Maybe there's one drawing you're having trouble with. You can always skip it for now and try it again another time. Drawing should feel fun, not like work!

I hope this book inspires you as much as the art books that inspired me.

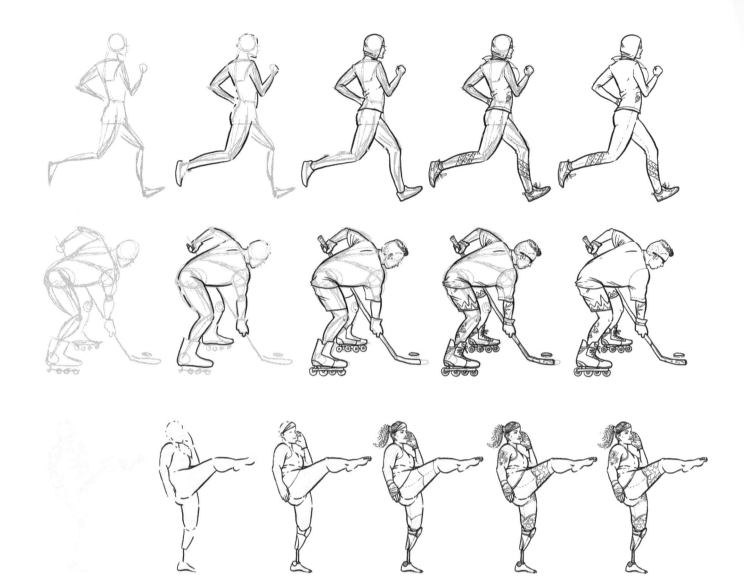
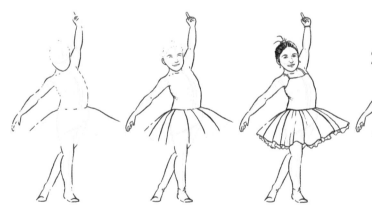

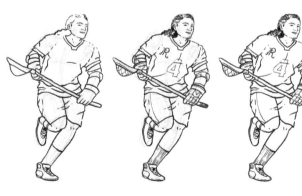

HOW TO USE THIS BOOK

Each activity starts with a brief lesson and step-by-step drawings to show you the process to help you learn by seeing examples. Think of your drawings as practice. Don't feel pressured to make an exact copy of my drawings. Feel free to use the activities as guidance, and if you feel like changing a figure's hair or outfit, or adding your own unique touch, do it. Unleash your creativity!

The materials you'll need are affordable and easily available. There's no need to buy an easel or the most expensive pens—I sure didn't. Here are some supplies I used in creating the activities, but you don't need them all. You can start out with a pencil, an eraser, and a sketchpad.

- Pencils

- Erasers

- Sketchpad or sketchbook: Mixed-media paper can take lots of erasing, markers, ink, and watercolors. A good size is 8.5x11 inches.

- Ink pens: Micron, Pentel, Sharpie fine points, or classic black Magic Marker

- Colored pencils: Prismacolor pencils are a great investment.

- Colorful markers

- Crayons

- Watercolor palette and brushes: You don't need lots of different colors, because you can make any color with the primary colors: red, yellow, and blue. Red and yellow make orange, red and blue make purple, blue and yellow make green, and so on.

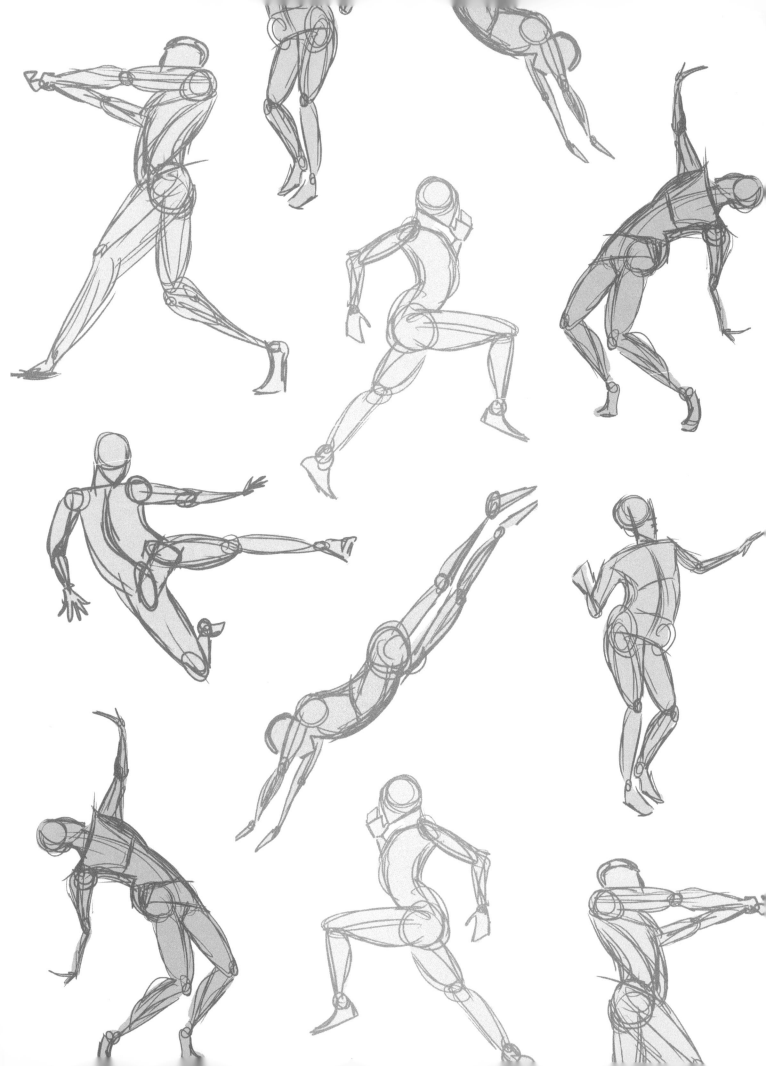

Part One

THE BASICS

Basic Shapes

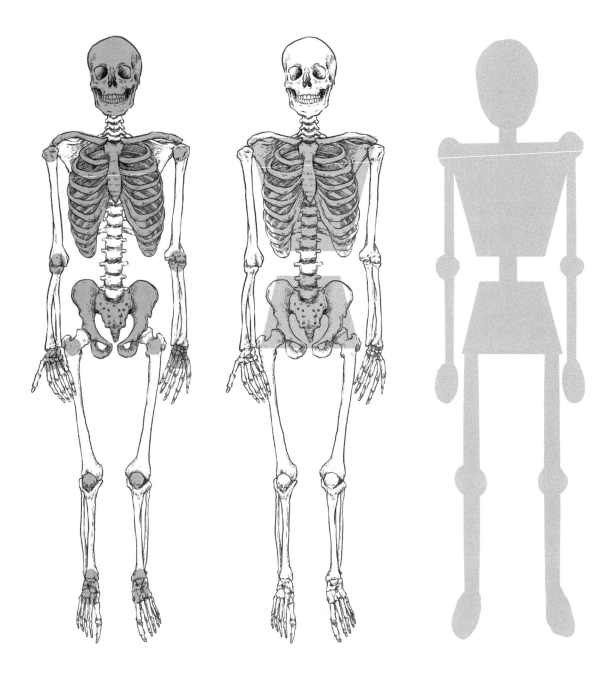

It's hard to draw a figure without understanding the human form underneath the clothes.

The human body has more than 200 bones and 650 muscles, but we'll focus on those most important for showing form and movement. We'll start with a stick figure and give it straight arms and legs. Let's make the torso an upside down trapezoid and the hips a right-side up trapezoid.

You can change the figure's pose and attitude by changing the angles of the hips and shoulders. For example, parallel lines will give you a still, standing figure, whereas lines slanting in opposite directions give your figure more life.

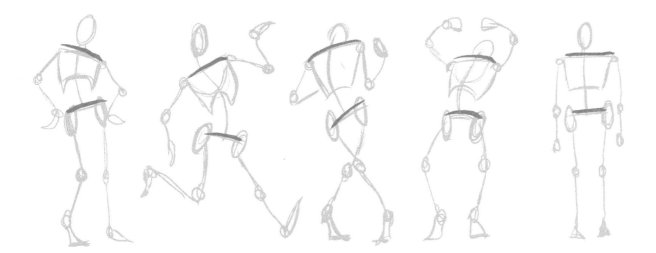

Next, connect the trapezoids to form a torso. Use sausage-like tubes to connect shoulders to elbows to hands, and hips to knees to feet. Play with the length and size of these shapes to create unique characters.

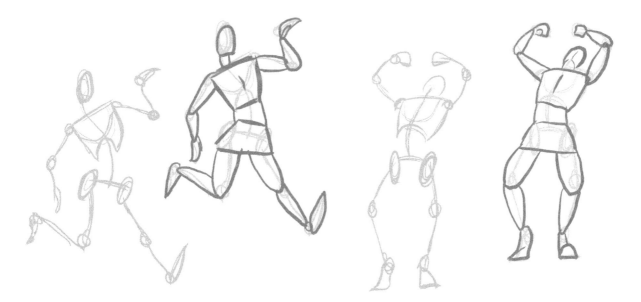

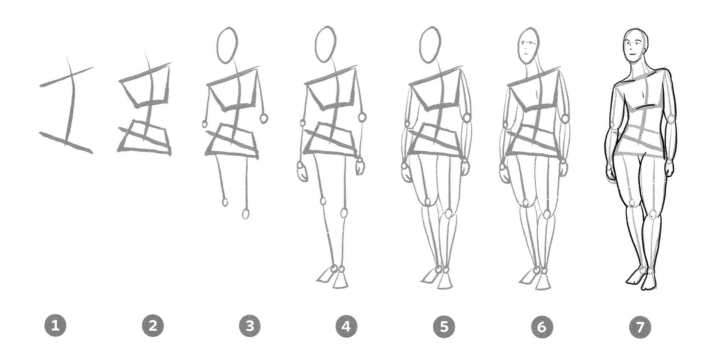

1 2 3 4 5 6 7

1 Begin by drawing lines for the shoulders and hips. Connect them with a line for the spine. Curving the spine gives the figure movement and life.

2 Lightly sketch trapezoids for the hips and ribs.

3 Next, add upper arm and thigh lines. The left shoulder is drooping, so the left elbow will be lower. The right hip is drooping, so the right knee will be lower.

4 Now connect the form to the limbs.

5 Use the sausage shapes to draw forearms, hands, shins, and feet.

6 Connect the trapezoids to create a waist, then draw the neck and head.

7 Use a black marker or pen to outline the whole body and see your first figure!

Practice

Now that we've tried one together, practice a few on your own. Remember, it doesn't need to be perfect. Have fun!

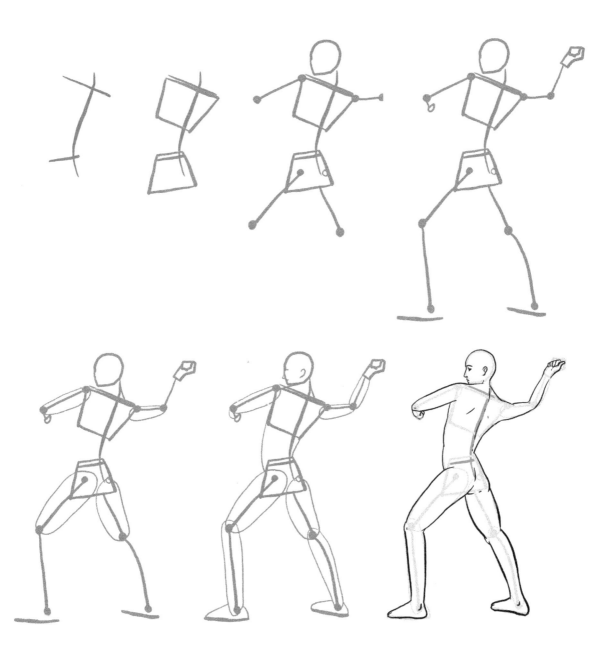

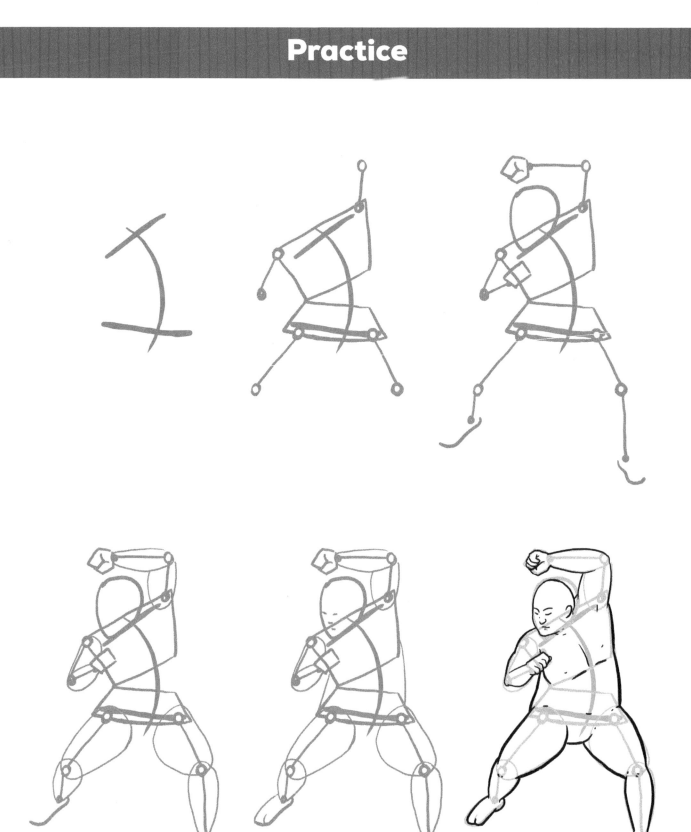

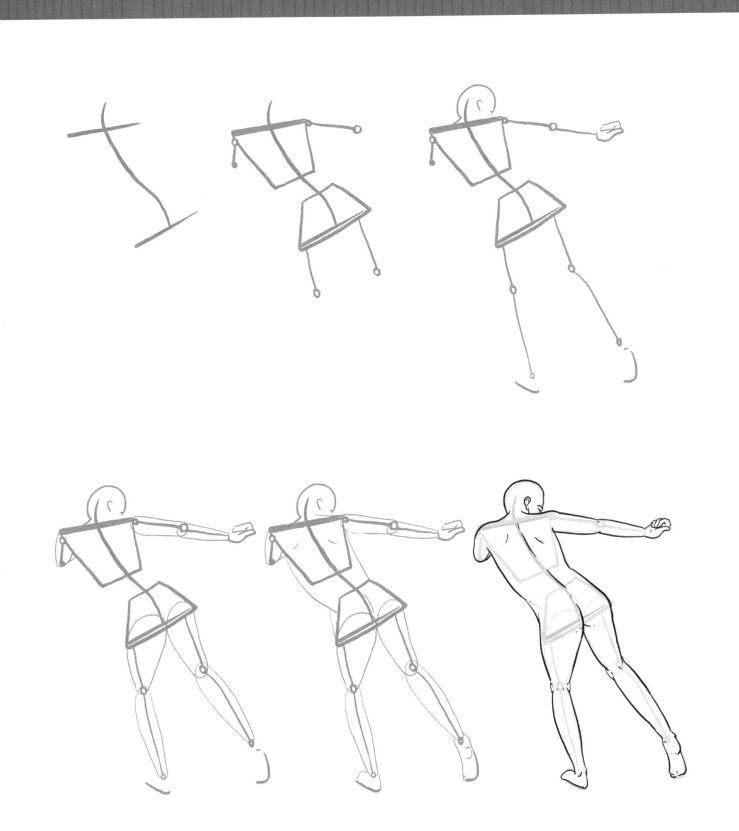

Using a Grid

Using a grid can help us draw a figure. We can use "heads" as a measurement for height. The average height of an adult is 8 heads. Generally, the elbows and belly button are 3 heads down, and the hands and mid-thigh area are 5 heads down.

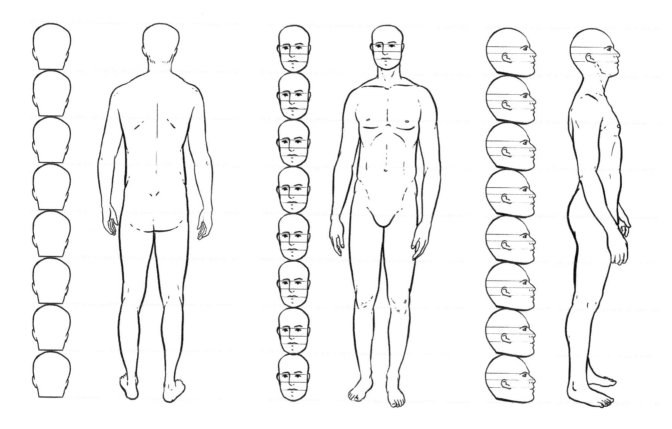

proportion: the relationship between the size of one thing and another

By changing the number of heads, we can draw different figures. A figure 4 heads tall could be a toddler, a figure 7 heads tall could be a senior citizen (we shrink with age), and a figure 9 heads tall could be a comic book hero.

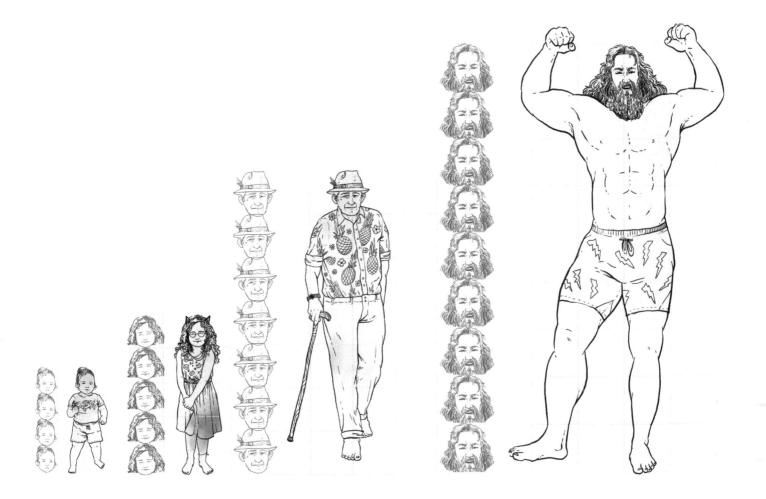

If we turn the grid on an angle, we can draw a figure standing sideways or three-quarters of the way and still keep its **proportion**.

We can even use grids to draw seated figures by shifting the boxes with the knees over slightly to the right. Then we can draw new lines to connect the knees to the thighs.

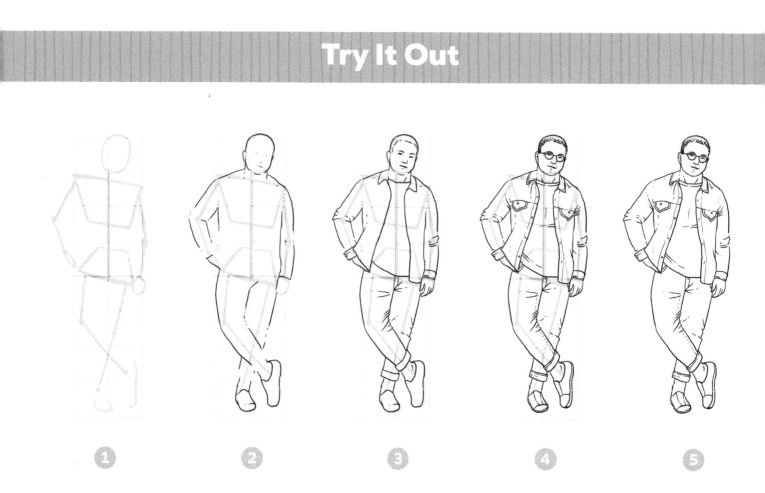

1. We'll make an 8-head figure, so draw 8 rows of 2 equal boxes to create a grid. The head fits in the top row, and the spine lines up with the center line. The shoulders and hips are mostly inside the grid, but it's okay if arms and legs are a little bit outside.

2. Time for the outline. Drawing little dashes in some areas means you can draw clothing folds later without having to erase a bunch of solid lines.

3. Finish the outline. Add little squiggles for clothing folds where you drew dashes. Add some lines to represent clothing. This figure wears a jacket, a T-shirt, and jeans. You can copy this or dress him differently.

4. Finish your figure with a few more details.

5. Erase the sketch lines.

Now that we've tried one together, practice a few on your own. Remember, it doesn't need to be perfect. Have fun!

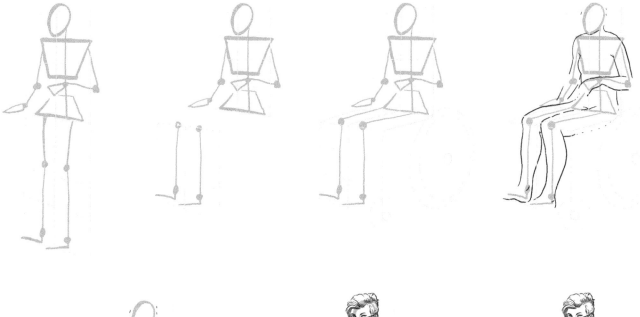

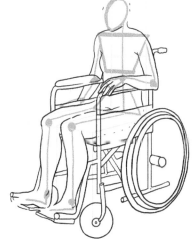

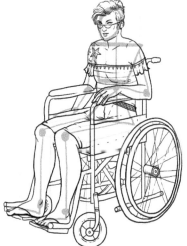

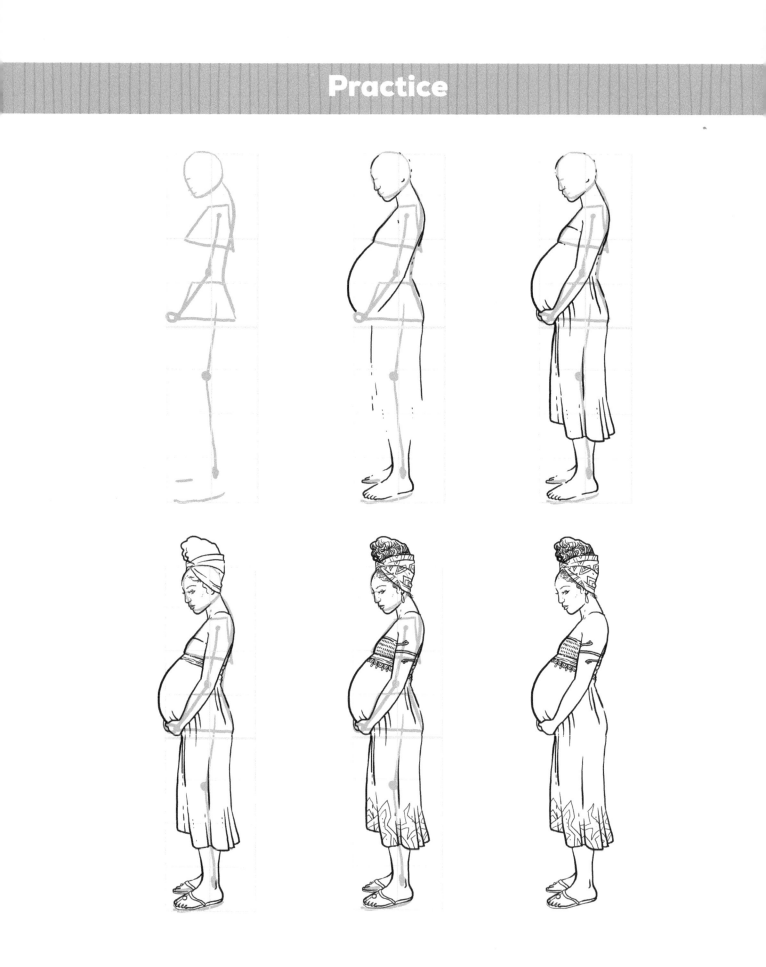

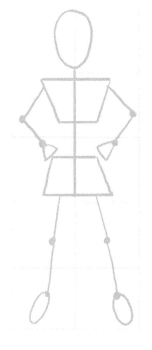
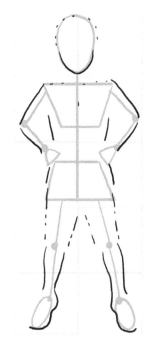
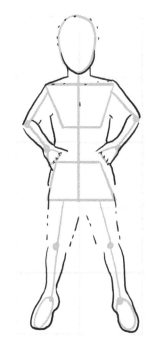
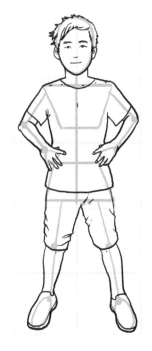
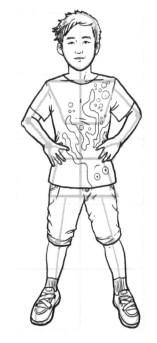
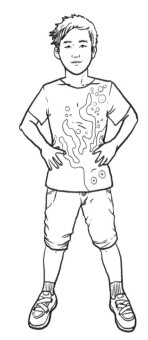

Defining the Body

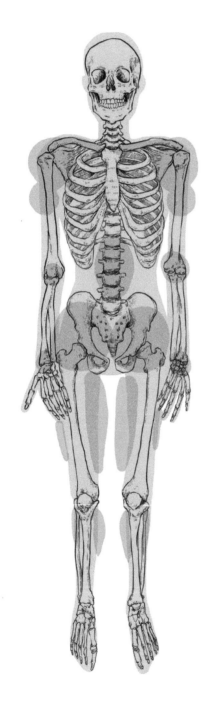
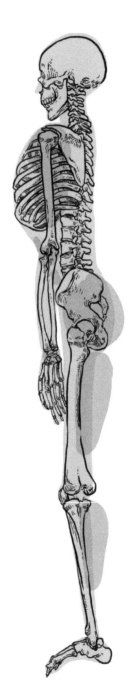

Let's expand on our skeleton from activity 1 (page 2). The blue area on the previous page is the basic shape, and the red areas are some important muscles. The size of the red areas can be different. Some bodies carry a lot of muscle in their chest, shoulders, and biceps, and their backs and chests are broad. Other bodies might have less-muscled arms but larger, rounder hips. Children often have little muscle, and babies are often round with baby fat.

 If muscles are working, they will be more noticeable and more defined. The back of someone resting looks pretty flat, but if they do a pull-up, you'll see those back muscles working. The more you keep this consideration in mind, the more detailed your figures can be.

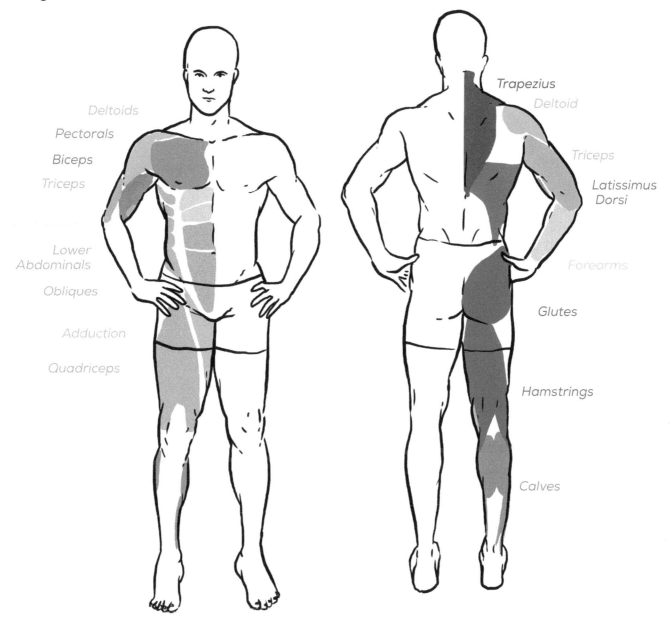

Deltoids

Pectorals

Biceps

Triceps

Lower Abdominals

Obliques

Adduction

Quadriceps

Trapezius

Deltoid

Triceps

Latissimus Dorsi

Forearms

Glutes

Hamstrings

Calves

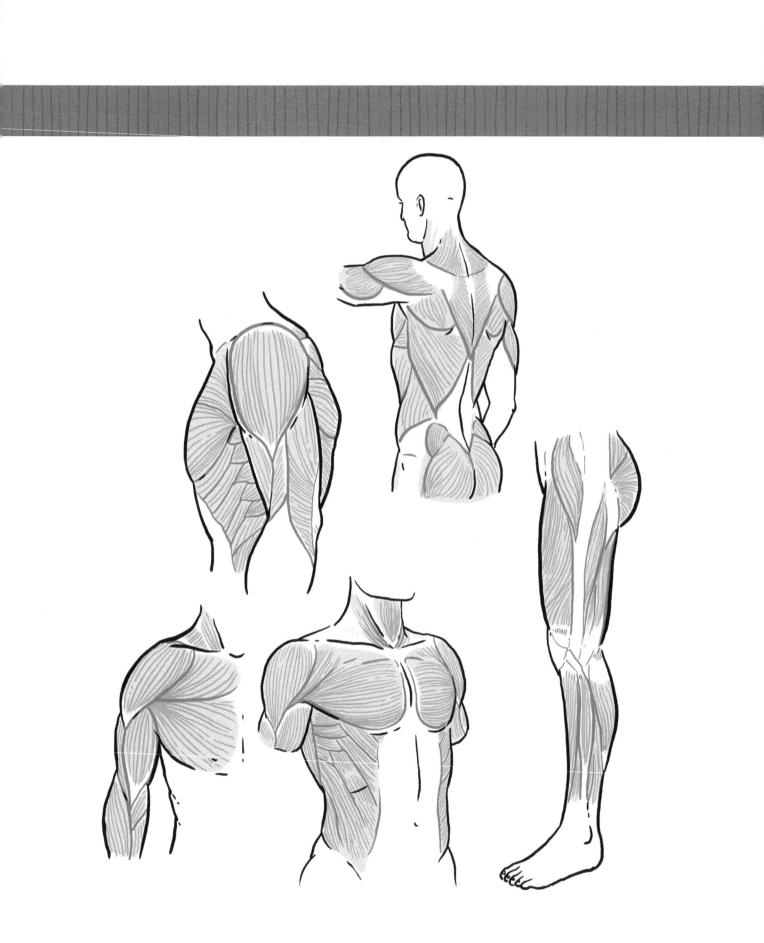

Try It Out

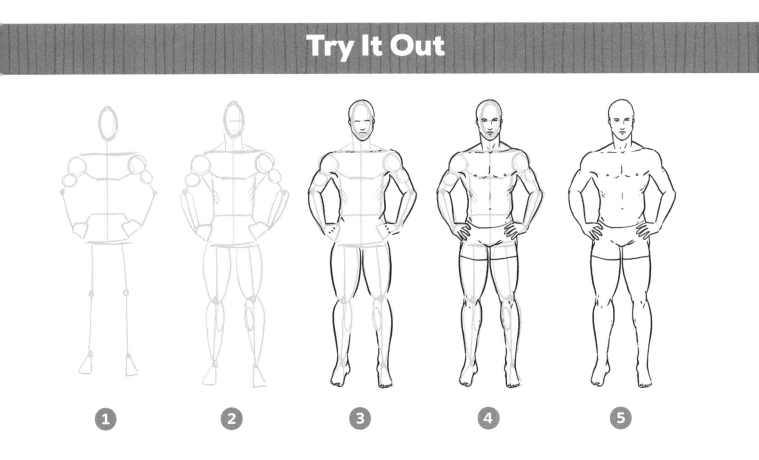

1 Start with a basic stick figure with boxy hips and chest. Add two circles in the upper arms for deltoids and biceps.

2 Finish the form with oval shapes for limbs, then add some circles inside the lower legs for calves. Connect the arms a bit lower on the torso, near the ribs to give the figure a broad back and an athletic look.

3 Next, draw the outline.

4 Add a bit of a curve to areas like the calves and upper arms to help show the muscles. You can also add detail to the chest and knees. Where major muscles connect, we can see small creases through the skin. You can show them with little dots and dashes.

5 Finish the figure by erasing your sketch lines.

TIP:
For these kinds of details, less is more!

Now that we've tried one together, practice a few on your own. Remember, your figures don't need to be perfect. Have fun!

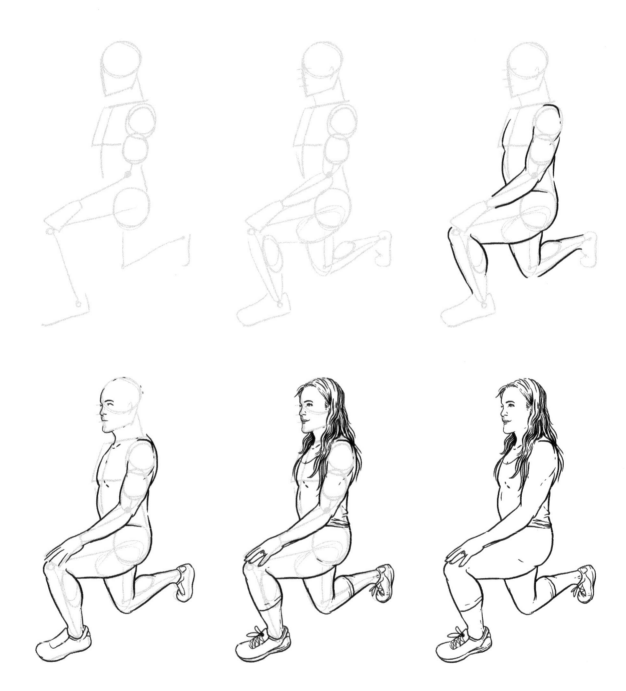

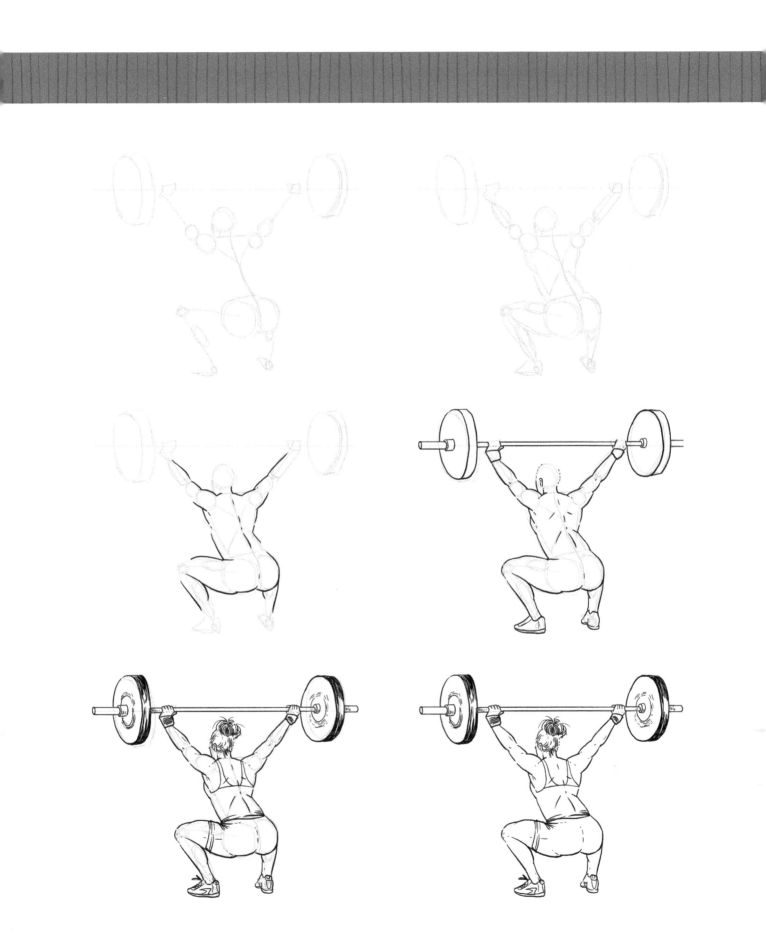

Ghosting

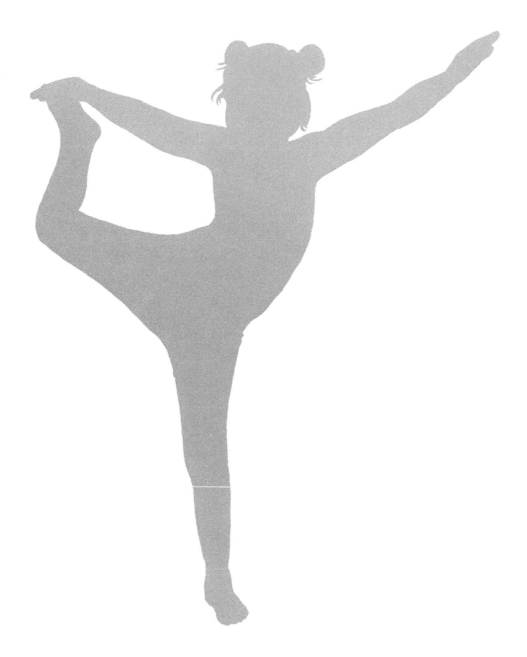

Ghosting is a way of looking at a figure as a whole shape.

Begin with a very light shade of pencil. Draw trapezoids for the torso, a circle for the head, and lines for the legs and arms. Thicken the lines for the upper arms and legs, then use slightly thinner shapes for the lower limbs. Think of the figure as **positive space** and the area around it as **negative space**.

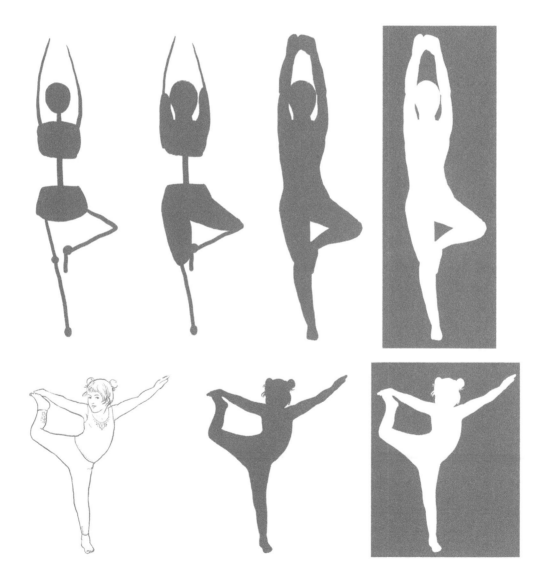

Once you've finished the "ghost," you should have a shadow figure. Now you can add shapes or line art to build up the form.

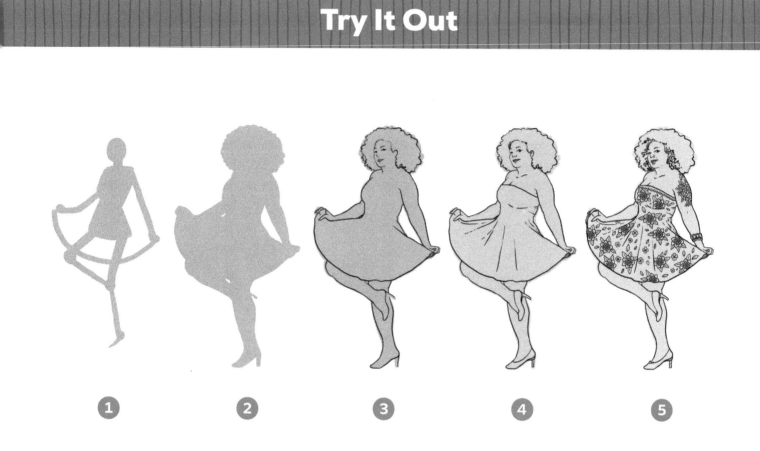

1 ② ③ ④ ⑤

1 Start by drawing the chest and hips of your ghost with a light shade. Next, make the pose of the arms with simple lines and a basic outline for the dress.

2 Fill out the figure, adding muscle and clothing. Remember the positive space in the gaps!

3 With a darker color, draw the main lines of the figure. Start defining the face and muscle in places such as the shoulders and legs.

4 Add detail, such as major folds in clothing and their portrait, or likeness.

5 Now have fun! I gave my figure a floral dress, a tattoo, and jewelry. You can do the same or something new.

Practice

Now that we've tried one together, practice a few on your own. Remember, your figures don't need to be perfect. Have fun!

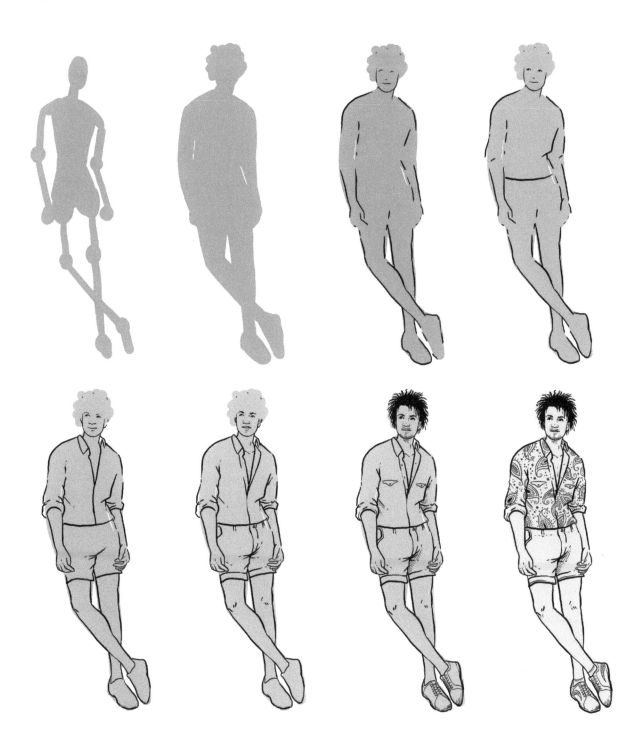

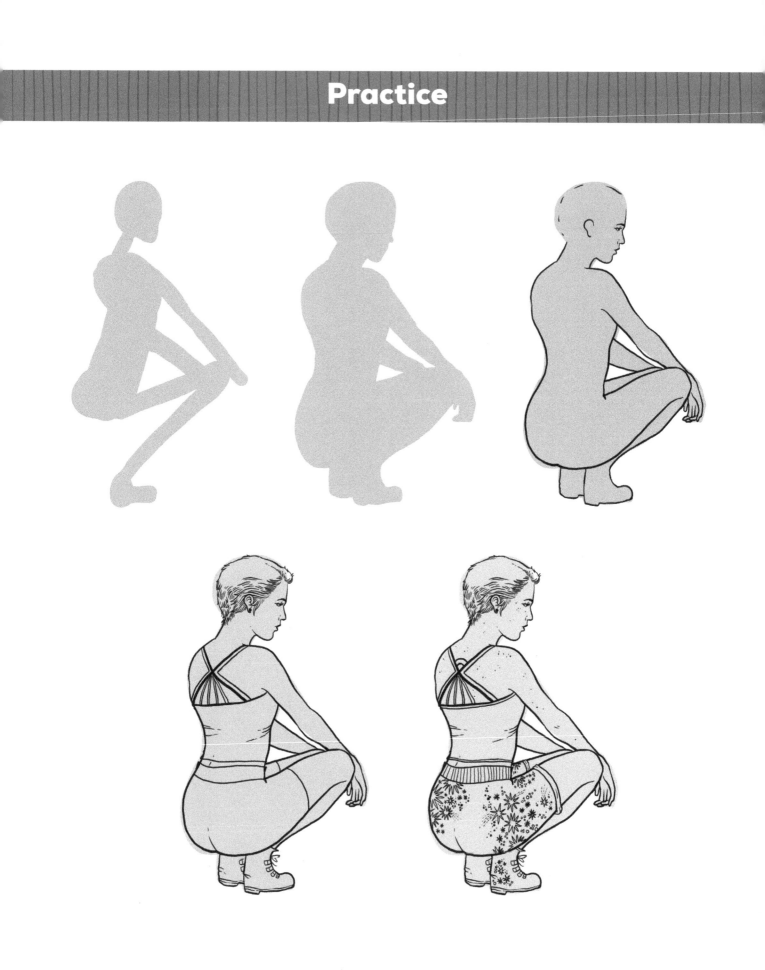

Movement

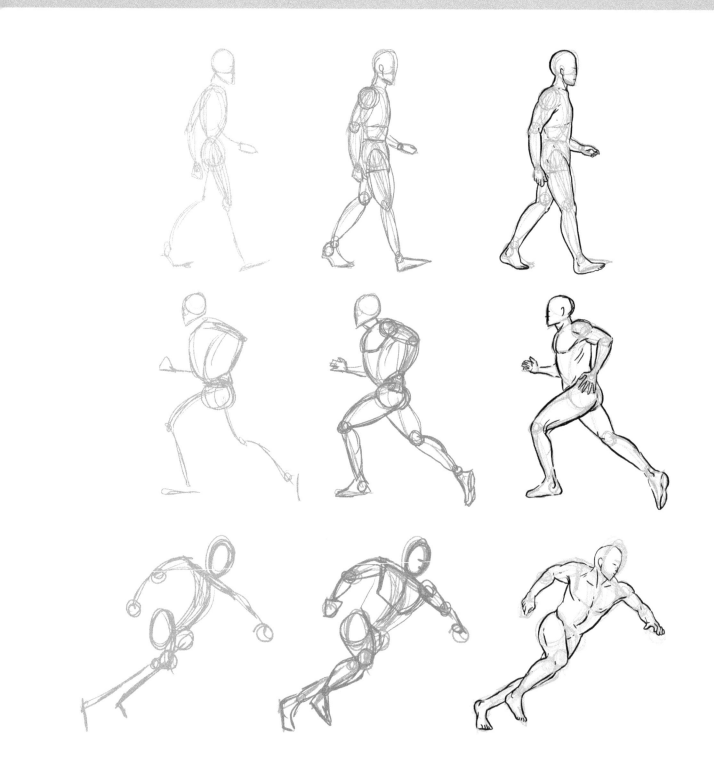

Now let's make our figures lively!

A still, standing figure has its feet directly under the head, hands at its sides, and shoulders and hips **parallel**. As the body shifts from one foot to the other, knees and elbows bend, and the spine becomes an **arch**.

When drawing movement, imagine yourself doing the same activity as the figure. Will you lower your hips? In which direction is your back bending? Will your weight be forward or backward? Which foot is bearing more weight?

Start with the basic stick form and don't focus on accuracy. Make quick, rough lines, exaggerating the pose to really show what's happening. After that, start adding shape. Then finish by drawing any final detail lines.

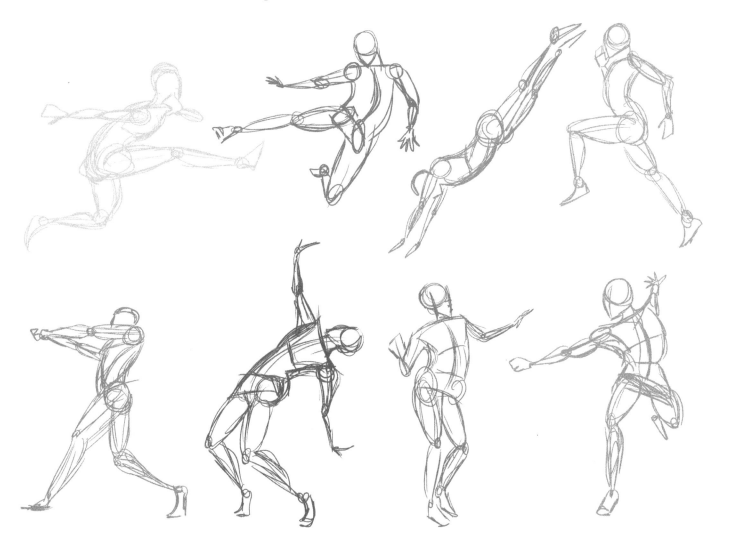

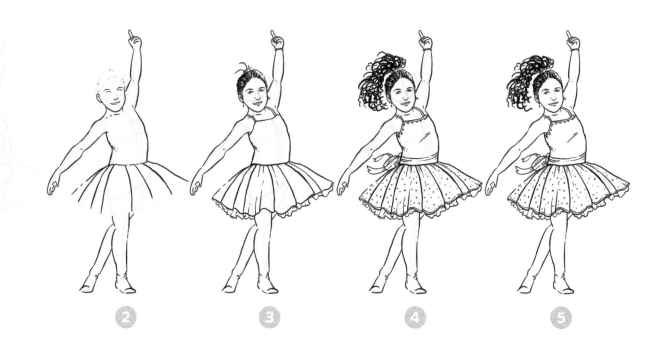

1 In light pencil, sketch the head and body, then add arms and legs. Pay attention to the curve of the spine. Remember, you can use a grid.

2 Use short dashed lines for the main body parts. My figure is in a skirt, so just draw enough leg to know what's there. Then finish drawing the basic body shape outfit, and add details for her face, fingers, elbows, and skirt.

3 Add details for her hair and portrait. Connect the skirt folds with a curved line. The more curves you add in the fabric, the more motion you'll show.

4 Now have fun! Because she is arching backward, her hair is being tossed behind her. Curls add movement. Then add detail to her outfit.

5 Finish the figure by erasing your sketch lines.

Practice

Now that we've tried one together, practice a few on your own. Remember, your figures don't need to be perfect. Have fun!

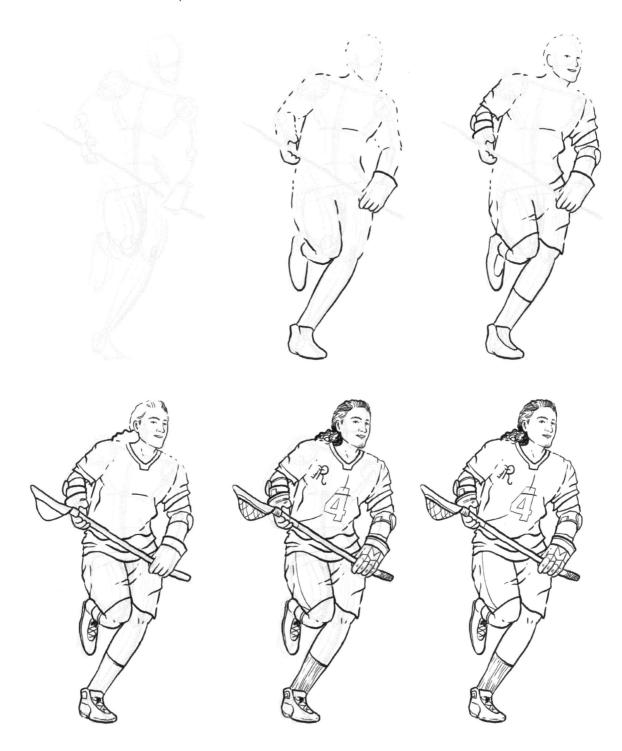

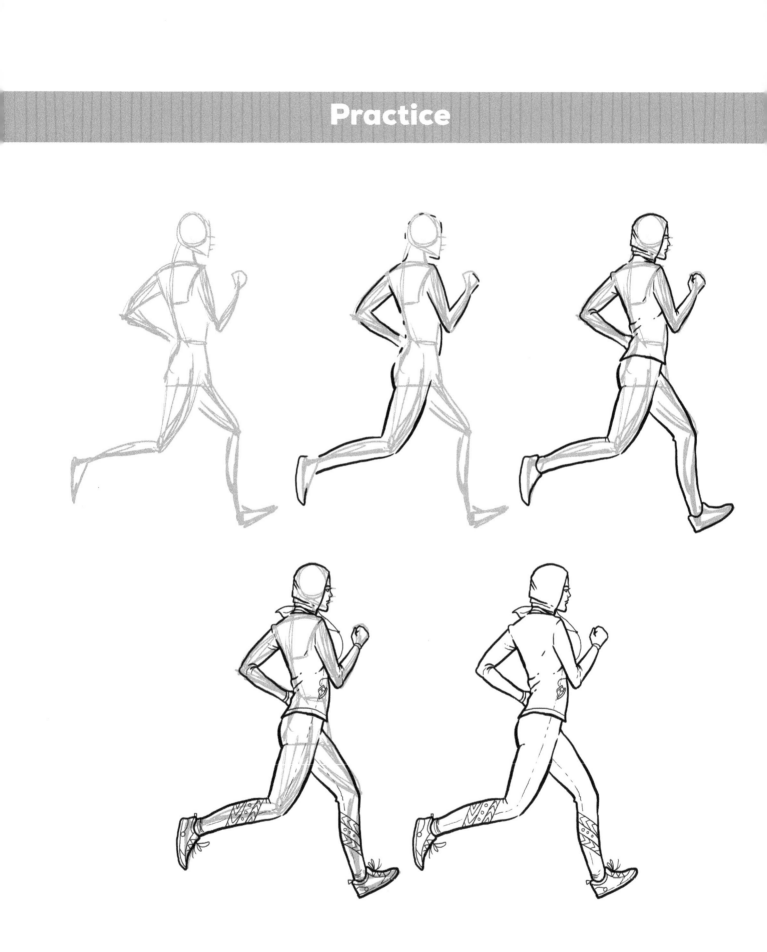

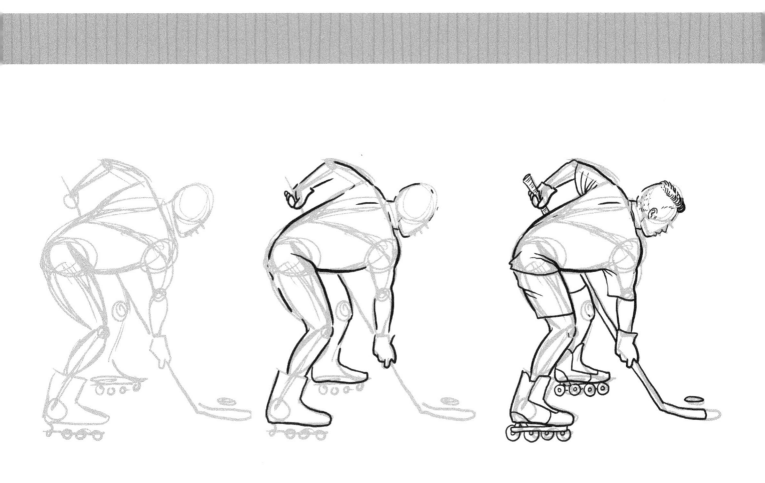

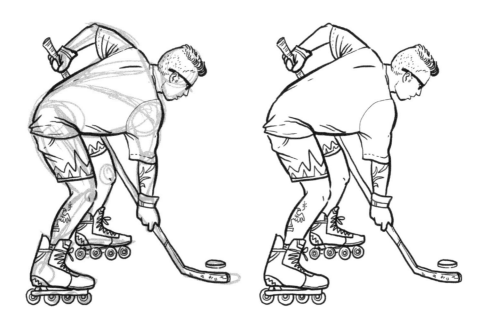

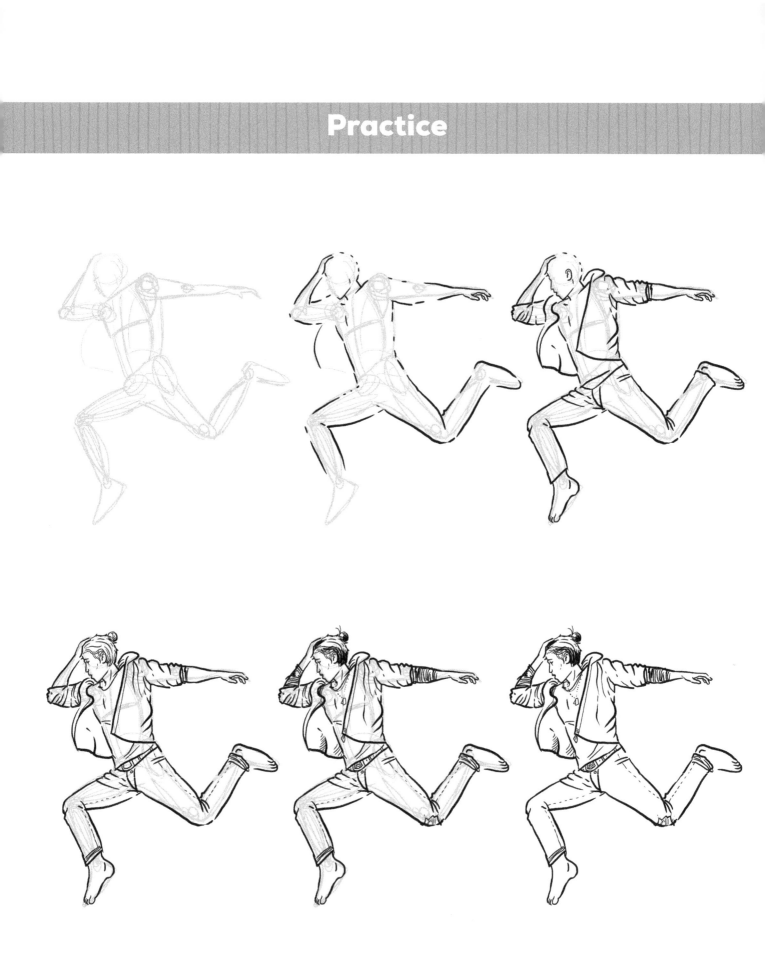

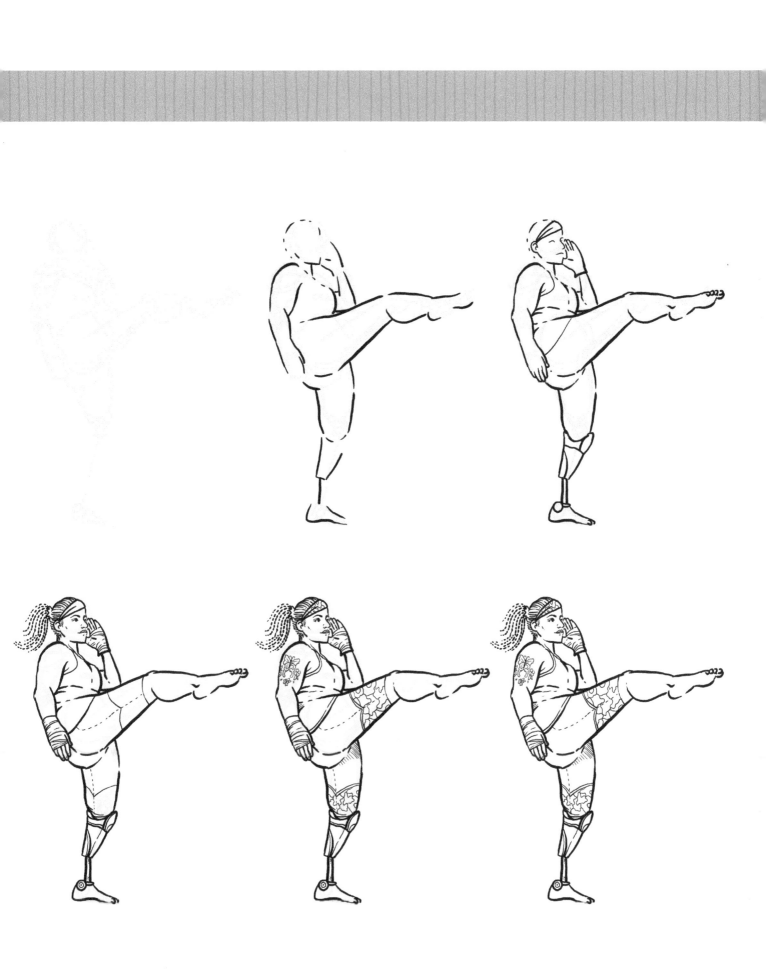

Point of View

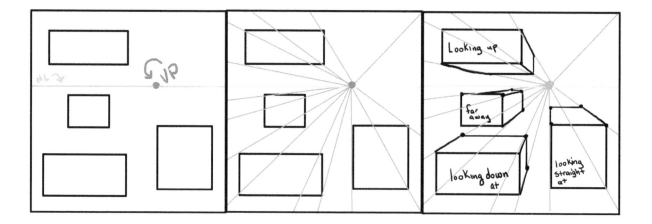

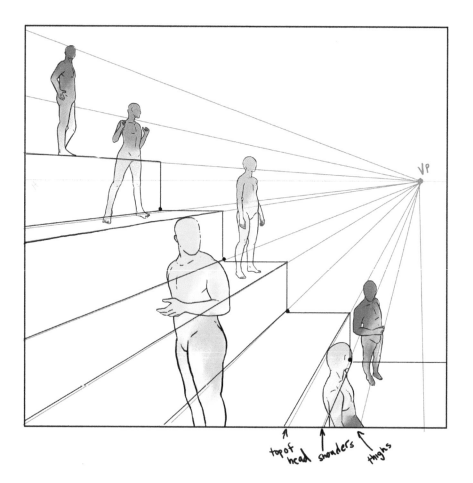

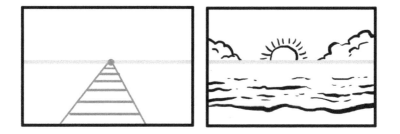

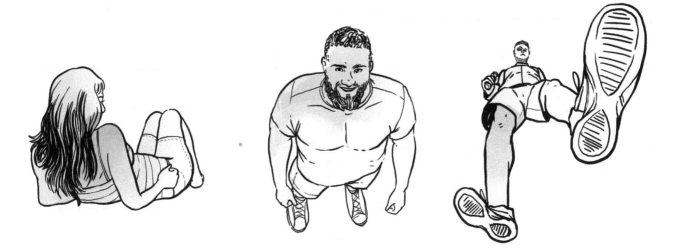

So far, we've drawn figures standing at the same level as us. But what happens when we look down from a higher position? What happens when we look up at a figure from below? These examples highlight **point of view**.

Imagine train tracks. The farther the tracks go into the distance, the closer together they seem to become. Eventually they seem to meet. That point in the distance is the **vanishing point**. It rests on the **horizon line**, a line that stretches across the page from left to right. Imagine you're looking at the ocean. Where the water and sky meet is the horizon line, and raising or lowering it can change our viewpoint.

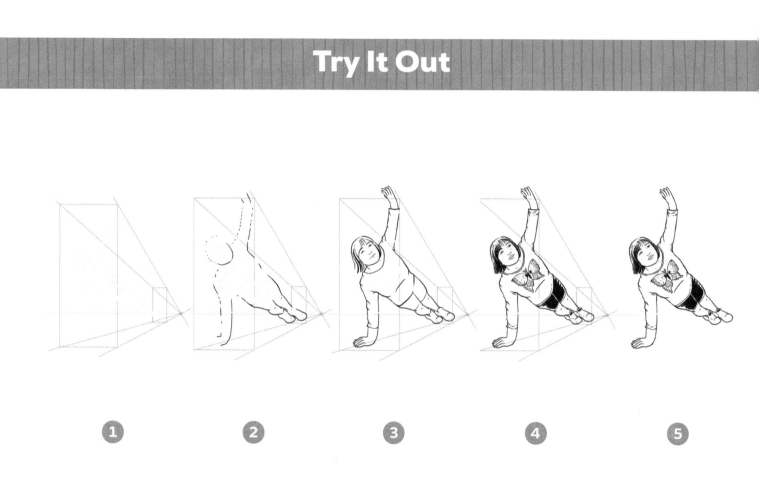

1 Let's put our figure in a box. Draw a horizon line and mark the vanishing point. Next, draw a tall rectangle to hold the head and shoulders. Closer to the vanishing point, draw a smaller rectangle for the feet. Connect the corners of the rectangles to the vanishing point.

2 Draw a stick figure in your box. The limbs are **foreshortened** and shorter than usual because they're far away. Draw the outline of the figure in dashes. Try drawing what's closest to you first.

3 Now build on those dashes, adding major lines and some clothing.

4 Finish the clothing and add details. The head and shoulders will have the most details because they are closest, and the legs and feet will have fewer because they're farther away. Complete the figure's portrait and outfit.

5 Finish the figure by erasing the sketch lines.

Now that we've tried one together, practice a few on your own. Remember, your figures don't need to be perfect. Have fun!

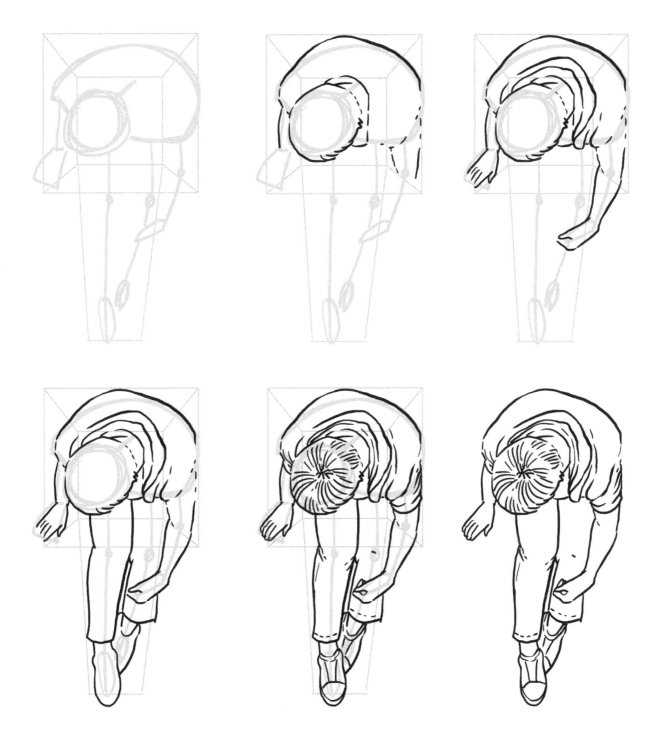

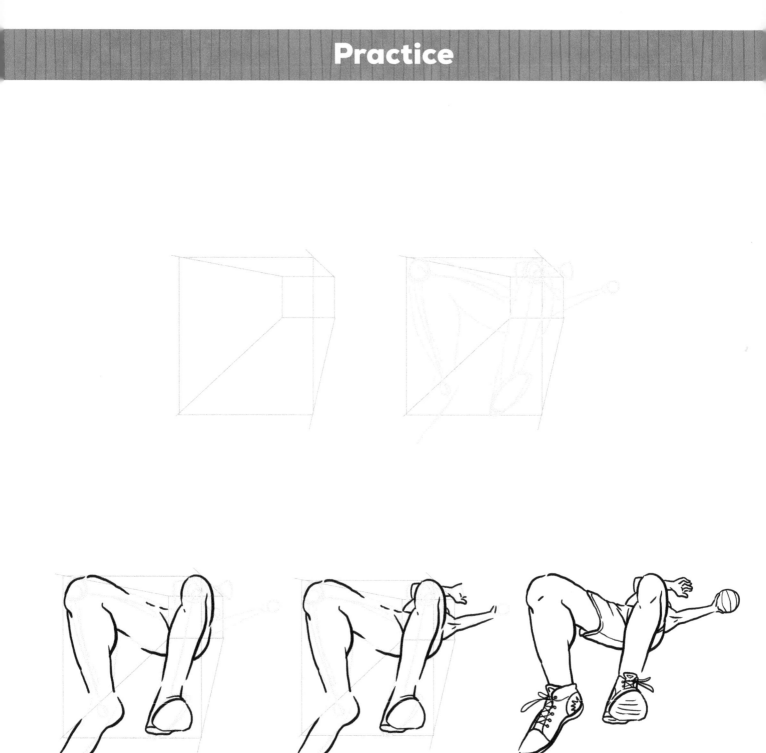

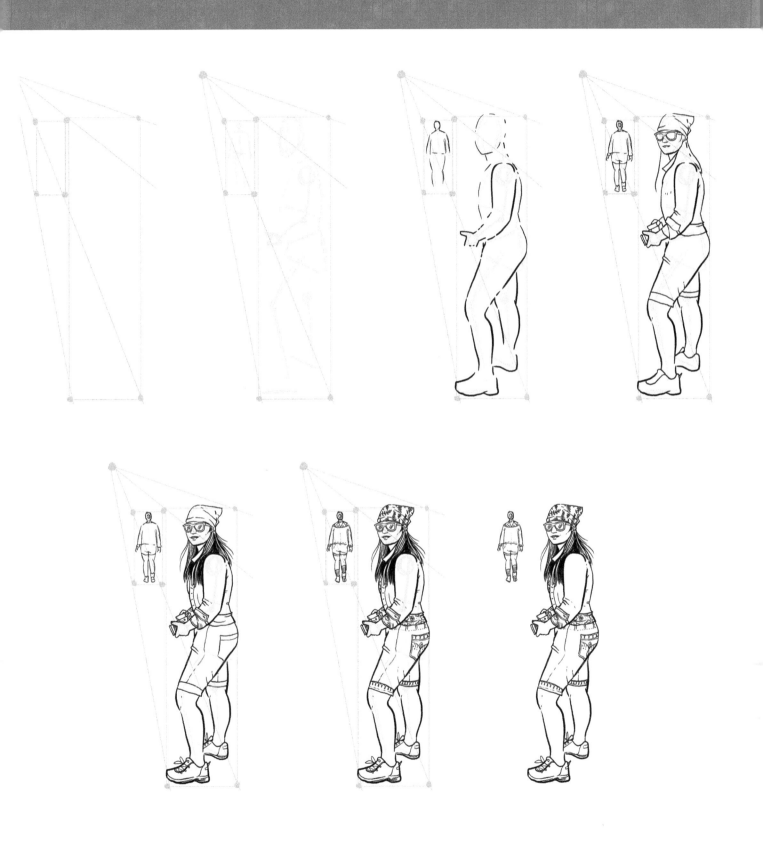

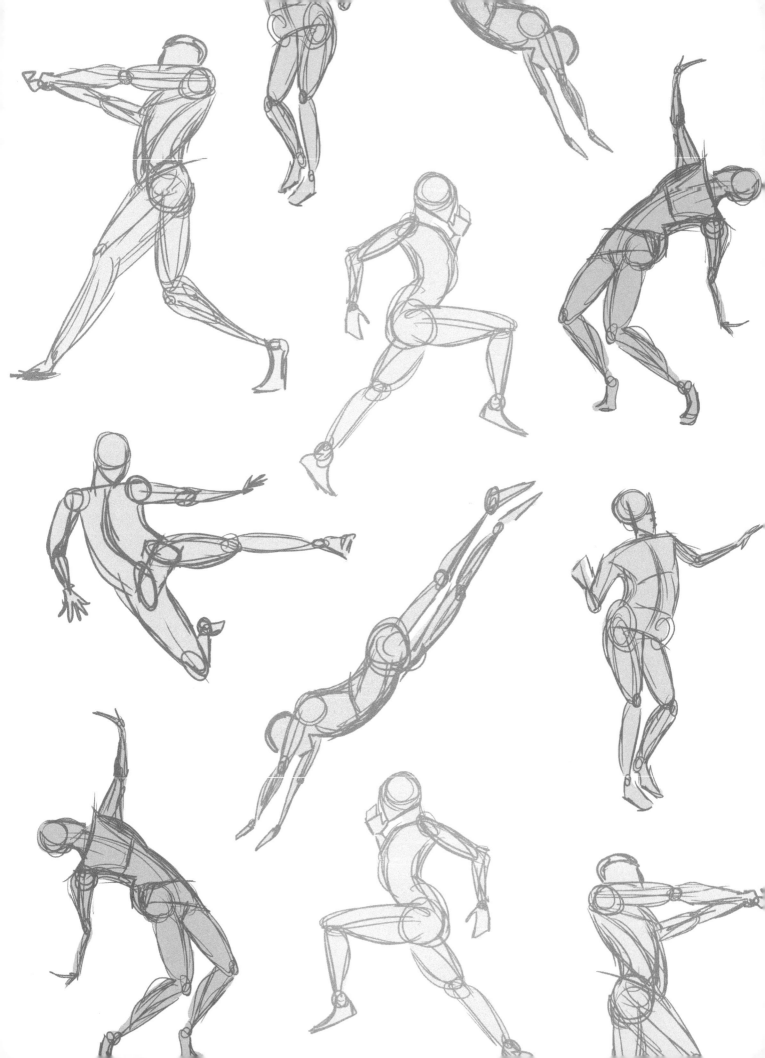

Part Two

THE DETAILS

Shading

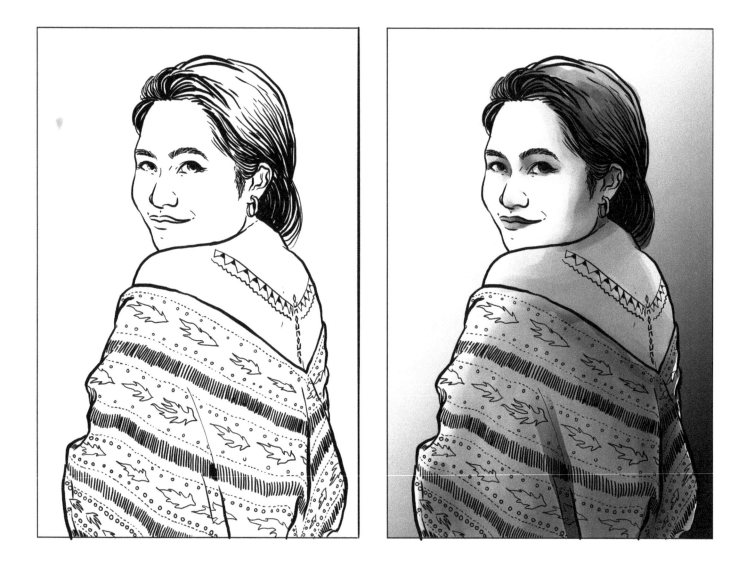

There's more to shading than just adding black! Shadows can be angular or round, hard or soft, and they help set a mood. They can jump from light to dark or gradually darken with many **midtones**.

In line art, figures can appear flat. Shading helps them appear more three dimensional. When shading, start out lightly and slowly apply more pressure as you move into your darkest **value**.

There are many ways to shade. In this activity, we'll use different mediums to learn how shading can add to our drawings. Grab a pencil, pen, or even some watercolors, and let's get started!

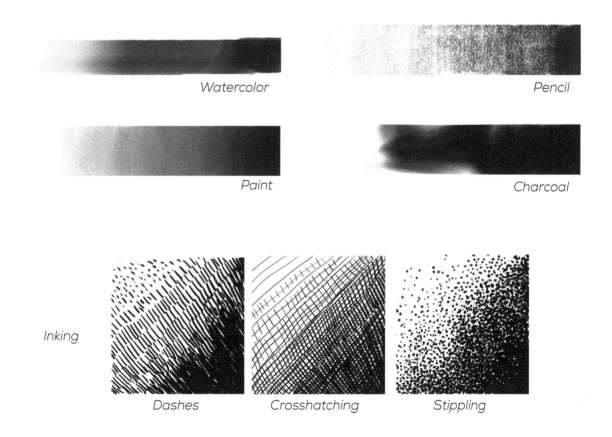

Watercolor

Pencil

Paint

Charcoal

Inking

Dashes

Crosshatching

Stippling

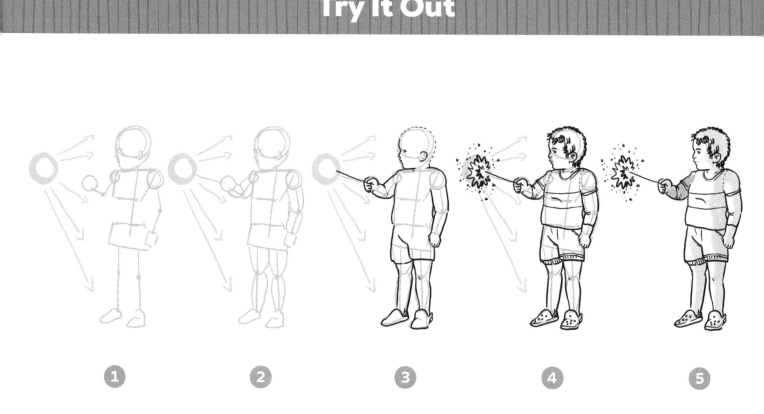

1. Gather a pencil, a waterproof marker or pen, an eraser, watercolors, a brush, a cup of water, and a paper towel. Lightly sketch in pencil a skeleton for this boy holding a sparkler.

2. Next, add ovals and circles to create a fuller figure.

3. Draw the outline in ink or waterproof marker.

4. Add details (clothing, hair, shoes, and face) to create your basic line drawing.

5. Now use very **diluted** black watercolor to create a light gray color for where the shadows are. The light is mostly catching his face, chest, and hips on the left, since that's where he's holding the sparkler. Most of his right side and his feet are in shadow, and the arm holding the sparkler is in shadow because it's facing toward his body, not the light. Finally, add a tiny bit more black to the diluted gray, and darken the areas farthest from the light—the back of his head, right shoulder, elbow, and leg.

Now that we've tried one together, practice a few on your own. Remember, your figures don't need to be perfect. Have fun!

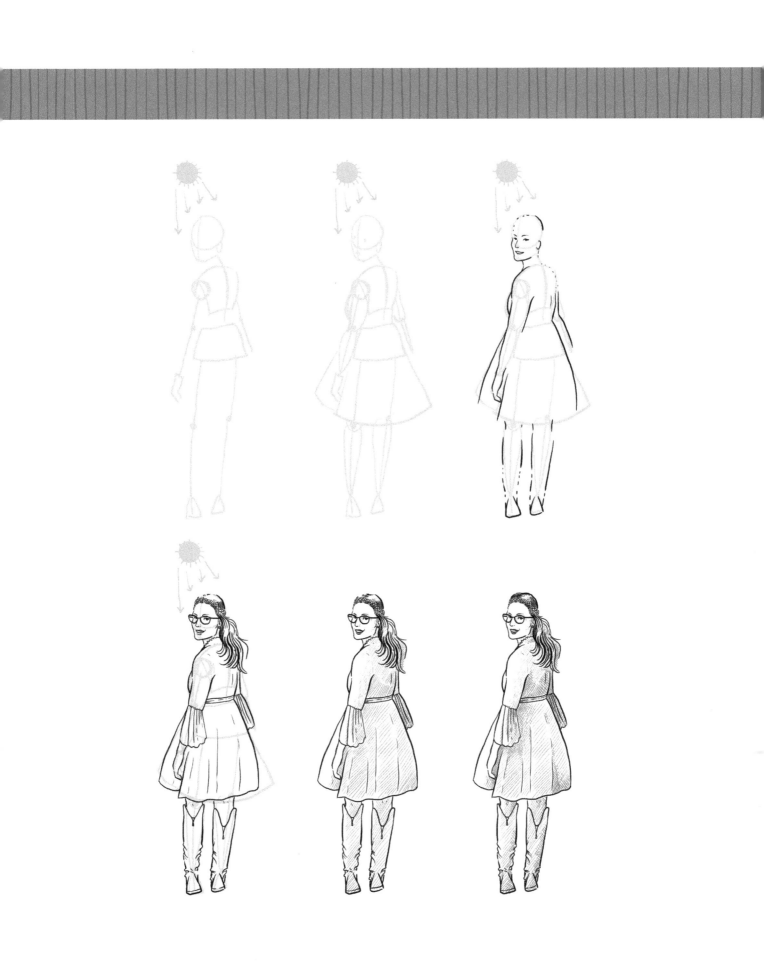

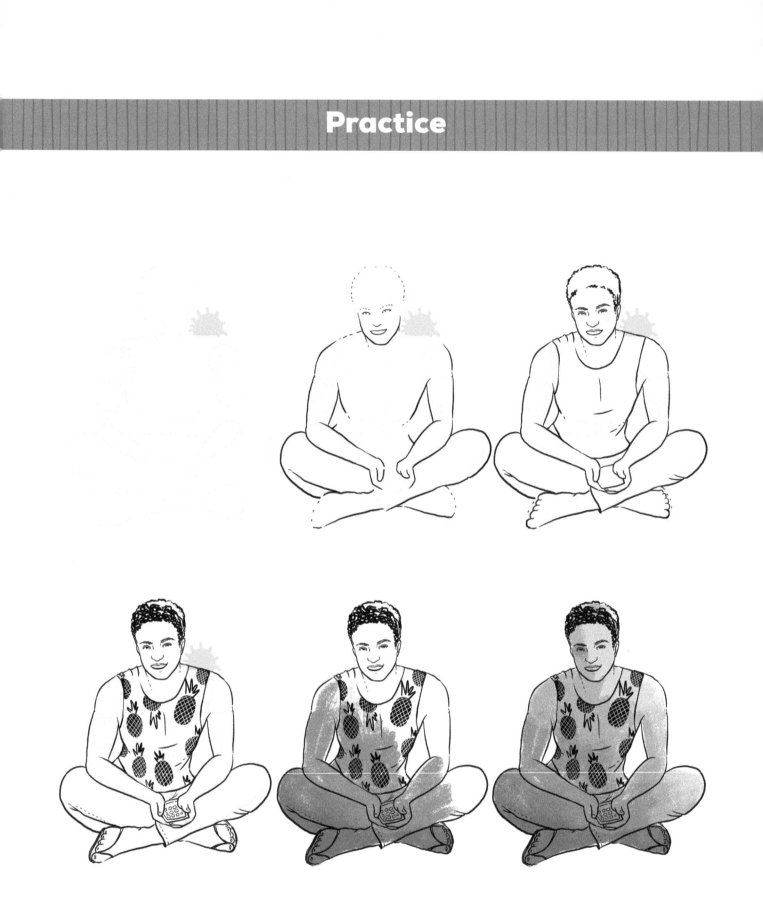

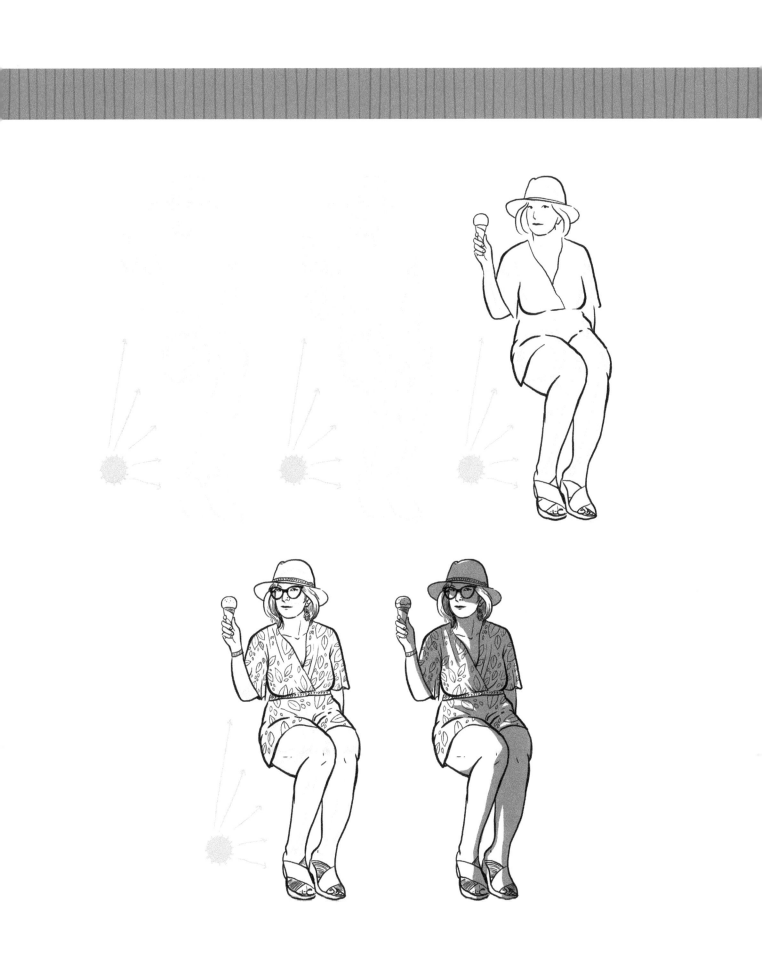

Adding a Face

Faces show thoughts, emotions, and attitudes. We all have noses, eyes, and mouths, but their different shapes, sizes, and placement help make faces unique.

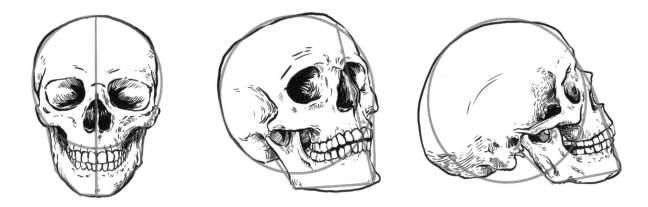

When drawing a head, start with a large circle and add triangular curved lines for the lower jaw. Then draw three lines in the center of the face. The top line, usually at the middle of the circle, hits the eyes and top of the ears. The middle line hits the nostrils and bottom of the earlobes, and the bottom line is where the mouth will be.

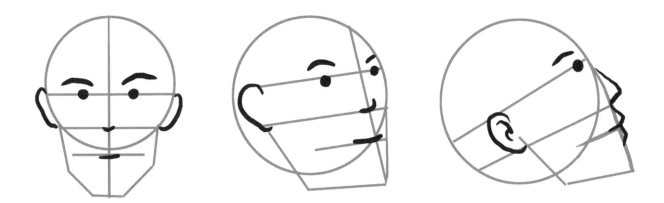

A good exercise is to create self-portraits using a mirror, sketching various expressions like smiling, crying, laughing, or screaming.

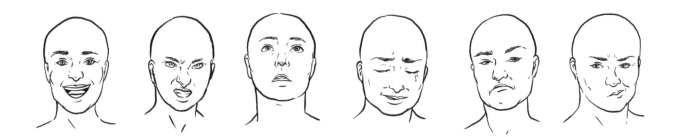

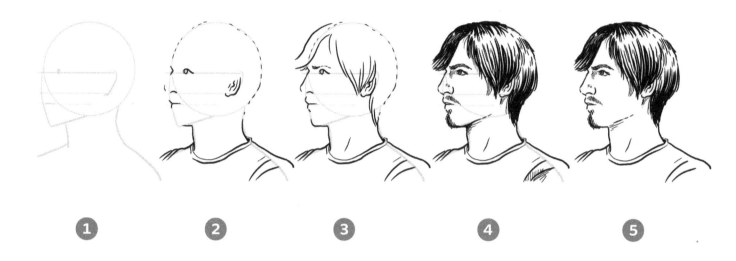

1 Draw the head in profile (side view), with a circle for the head and a triangle for the jaw. Then draw the three lines where the features will be.

2 Try drawing the features first, then the head shape. Draw the upper eyelid and eye, then the nostril, and finally a curved dash for the tip of the nose. The lips meet like a sideways V (>) and usually are the same length as the nostril. Add the ear.

3 Now connect the forehead to the nose, and lips to chin. Add an indent at the eyes and between the chin and mouth. Add some hair strands, too.

4 Add thick strokes for the hair and some dashes or stippling for facial hair. Do a bit of shading near the eyes and under the chin.

5 Finish the figure by erasing the sketch lines.

Now that we've tried one together, practice a few on your own. Remember, your figures don't need to be perfect. Have fun!

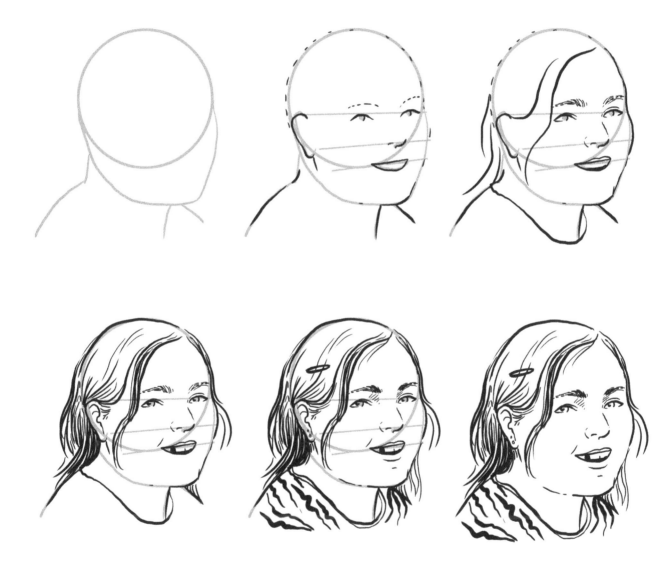

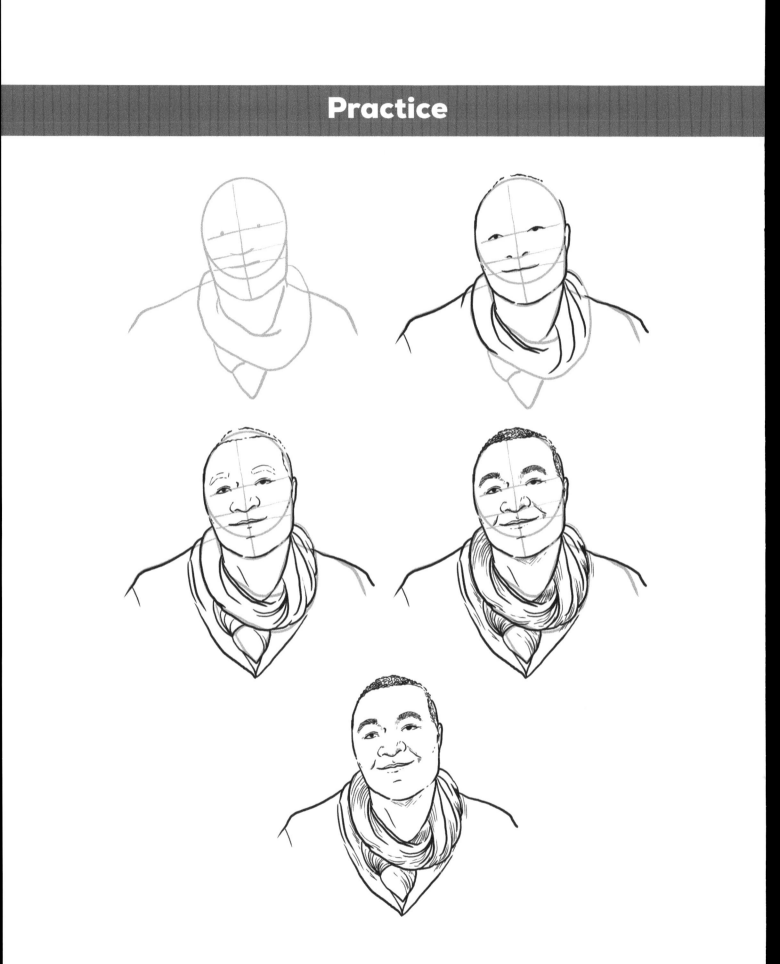

Making a Scene

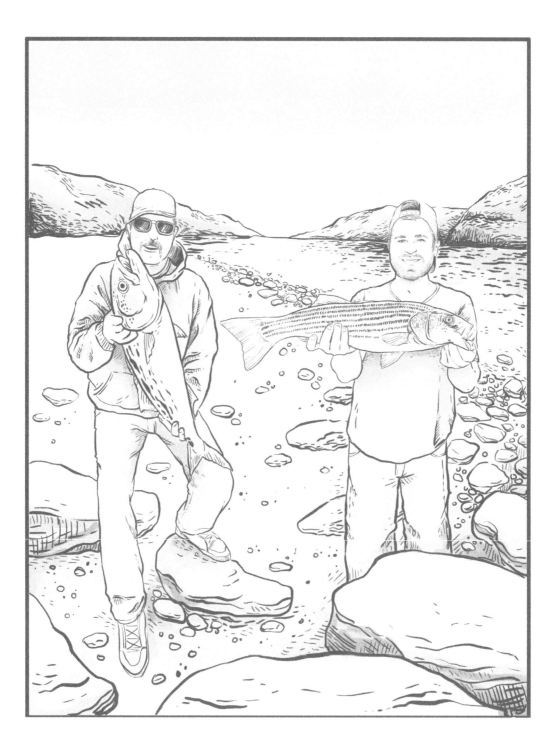

We can now use past lessons to make whole drawings. Using the Movement activity (page 28), we can show figures relating to one another. We can place them close together or at a distance using perspective (page 36). We can also use shading (page 44) to suggest time of day or create a mood.

The **foreground**, where a lot of main storytelling happens, contains the finest details. The **middleground** often shows where the scene takes place and has secondary figures. The **background** shows setting and holds less detail.

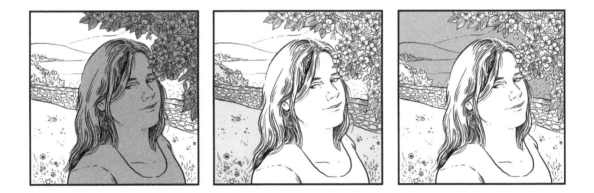

Composition is how we arrange a scene. You can start by drawing a shape or letter and putting all the important subjects and details inside. Outside the shape will be the setting, small details, and muted colors.

Try It Out

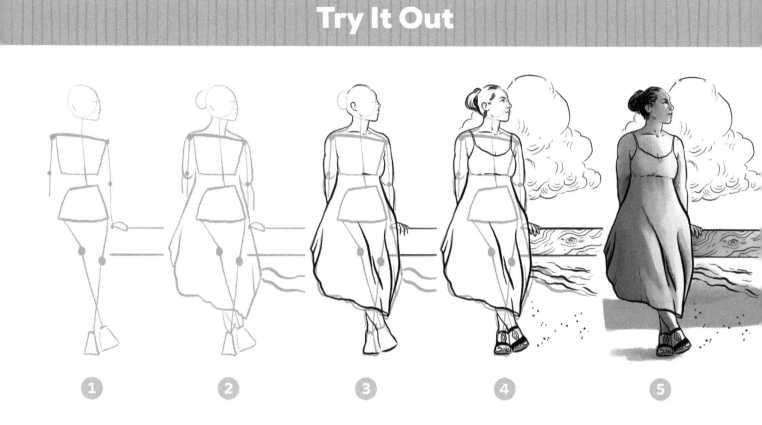

1. Start with a stick figure. For this exercise, we'll draw a woman at the beach.

2. Use short dashes for the main body parts. She's in a skirt, so don't draw too much of the leg.

3. Fill in the basic shapes of the body, then outline the dress. Add some waves.

4. Draw a basic outline of the figure and the dock she's leaning against. Finish with final lines and details.

5. Time for shading! The light is coming from the right, as if she's watching a sunset, so try to have your shading show that.

 TIP:
 Artists often use a technique called atmospheric perspective. This creates an illusion of depth by showing distant objects as paler, less detailed, and usually a bit bluer.

Practice

Now that we've tried one together, practice a few on your own. Remember, your figures don't need to be perfect. Have fun!

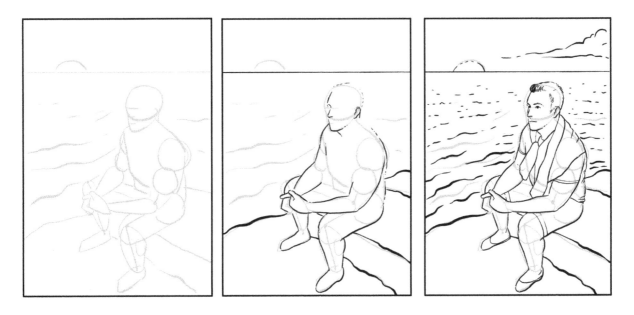

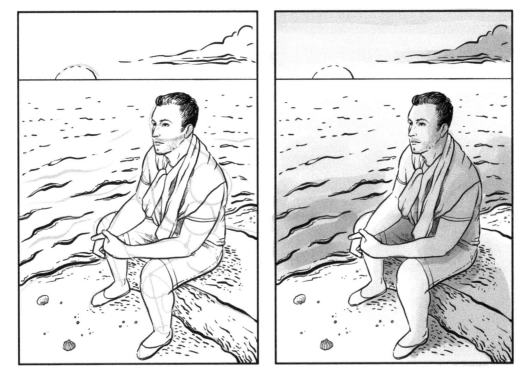

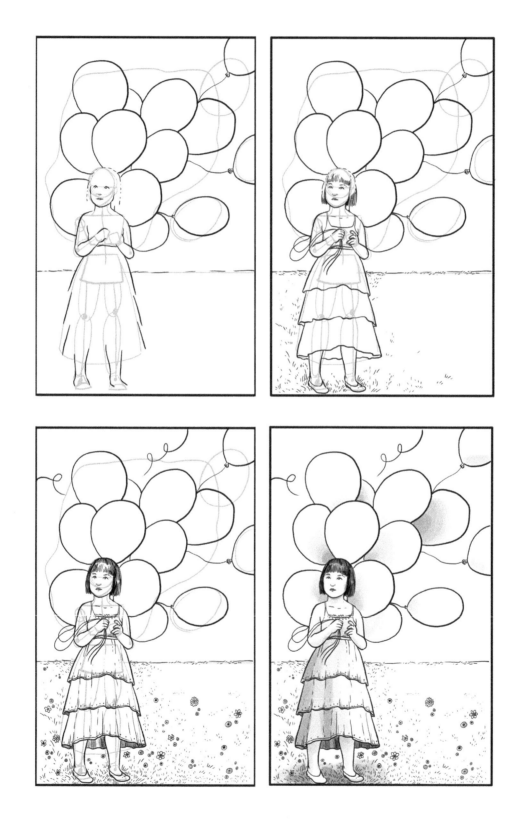

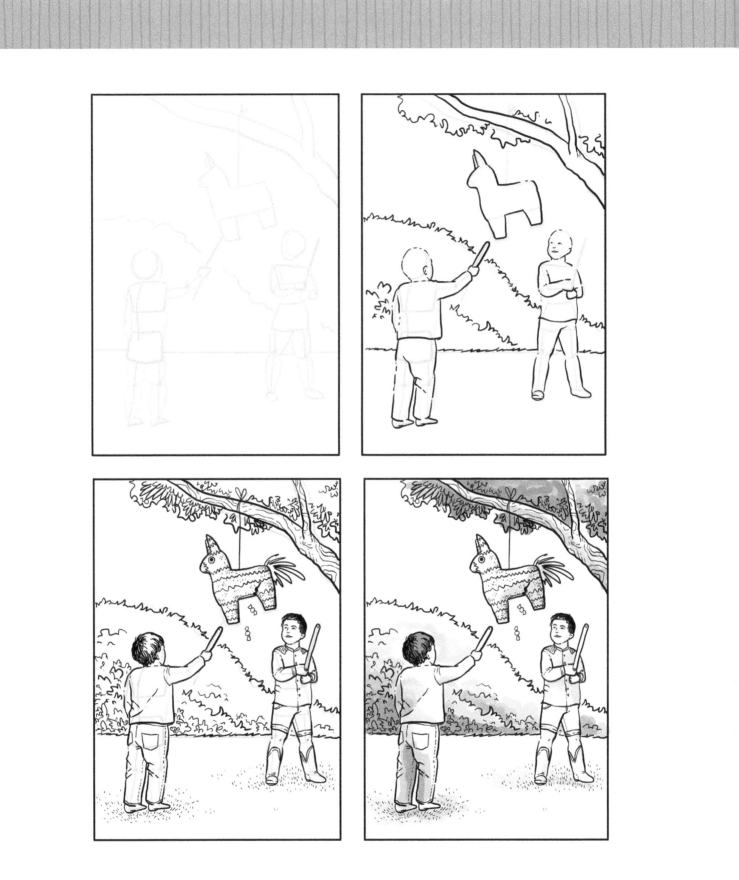

Photo Aid

The advantage of using a photograph to practice drawing is that you can always refer back to the photo, unlike a live subject, so there's no rush.

When taking a photo for reference, or using one you already have, think about your past lessons. Try taking a picture that shows movement. Avoid figures wearing all black or baggy clothing, because it can be hard to see their shape. Avoid cutting off the feet, arms, or half the head. Try taking the photograph in sunlight to get good highlights and shadows. Using flash can overexpose things.

Museums are great places to take photos for reference. They have wonderful collections of sculptures, armor, and taxidermied animals, beautifully lit and posed.

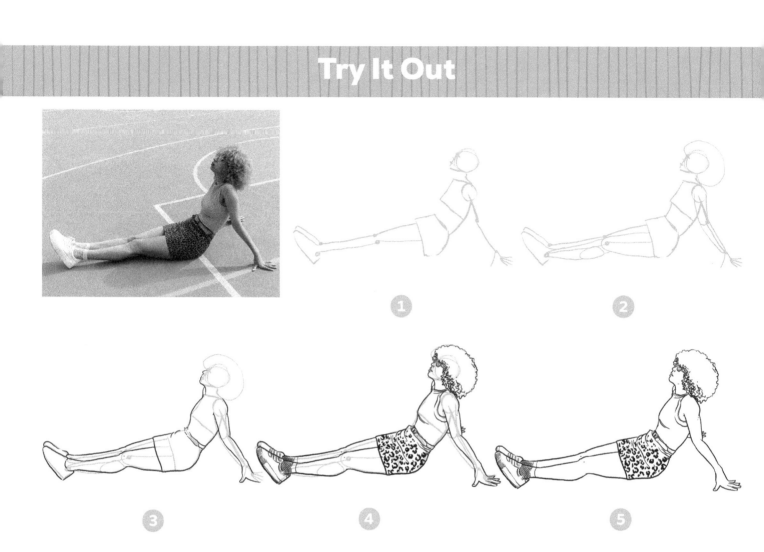

1 Start with a simple stick figure to capture the form.

2 Use basic shapes to finish and fill in the form.

3 Draw the simple lines of the figure and its clothing.

4 Complete the details for the face, clothing, and patterns.

5 Finish the figure by removing the sketch lines.

Practice

Now that we've tried one together, practice a few on your own. Remember, your figures don't need to be perfect. Have fun!

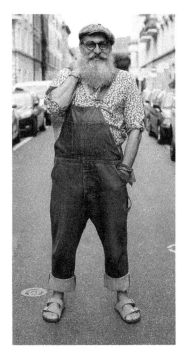
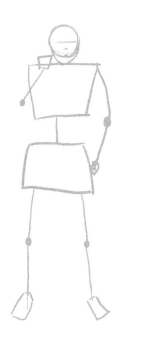
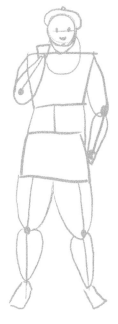

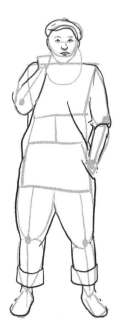
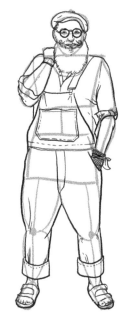
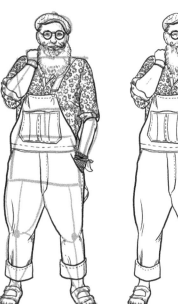
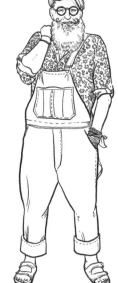

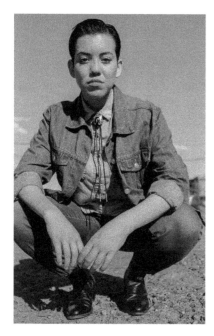

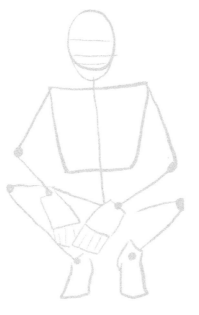

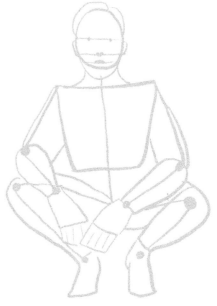

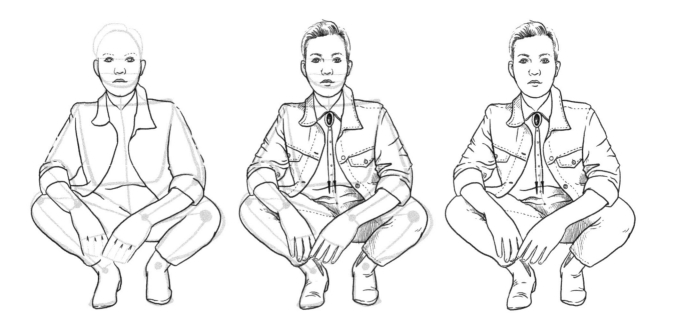

Statues are great to use because of their dramatic poses and lighting. Try practicing with this photo.

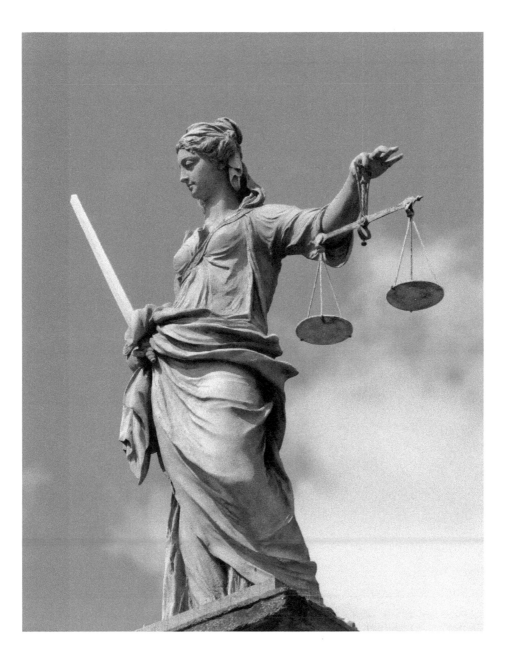

Photos with friends are fantastic to work from, too. Try practicing with this photo.

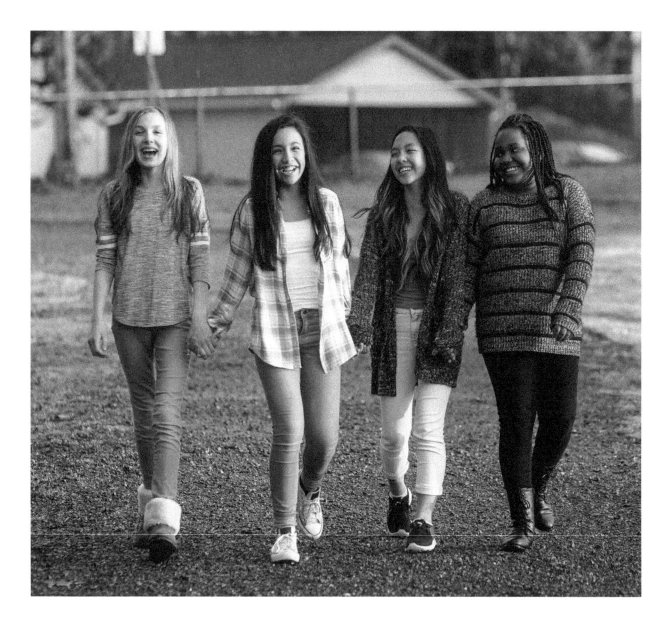

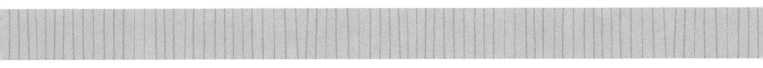

Street photography can result in something really dynamic. Try practicing with this photo.

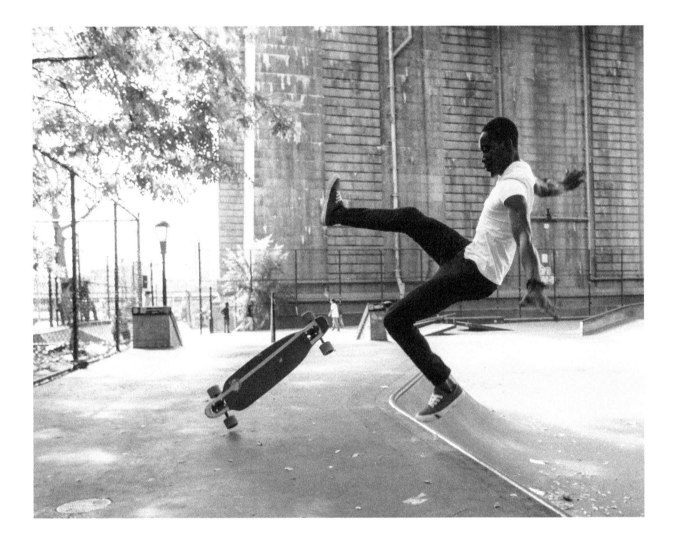

In Your Home

First, you need a willing model, perhaps a family member or friend. Pick a well-lit spot so that you can see clearly and get interesting shadows. Try outdoors or inside near a window. Just make sure your subject is comfortable.

Begin with a stick figure, then sketch any surrounding setting you'd like. It's okay to start out messy, drawing quick planning lines and fuller lines. There's plenty of time later for final, detailed lines.

If your model is holding a difficult pose, set a timer. At 10-minute intervals, allow your model to stretch and drink some water. Use your model as a guide and have fun drawing what you see and imagine. Maybe your figure is fighting a dragon or exploring space! Remember, your figures don't need to be perfect.

Turn a friend into a superhero! Pose them in a way that shows off their superpower. Can they fly? Do they shoot lasers out of their eyes?

1 2 3

1 Position your model next to a window with plenty of daylight. Have fun dressing them up. Maybe you have a cape, a Halloween costume, or cool jewelry.

2 Sit close to them and start your quick sketch in light pencil. Sketch a hint of their costume and powers, too. Once you have the figure drawn out and you find yourself looking less and less at your model, let them take a break from posing. Continue drawing details, then add color. If there's something you're unsure of in your drawing, kindly ask your model to re-pose.

3 Add basic shapes to fill out and finish the sketch.

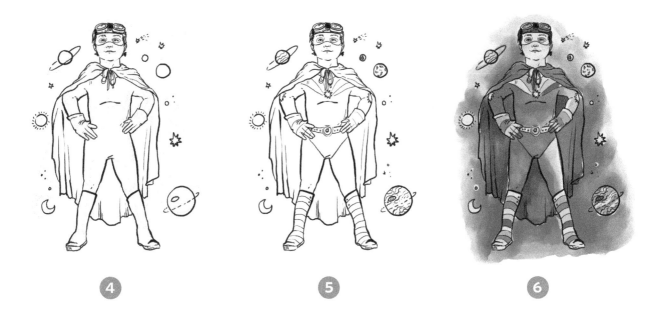

4 Now draw your major outlines with a black marker, pen, or colored pencil that doesn't smear when erased.

5 Erase your pencil sketch, and then finish up details and fine lines.

6 Now it's up to you. Color in your lines with marker, colored pencils, or crayon. Remember to show light and shadow!

Practice

Here are some other scenarios you can do at home using family and friends and objects around the house. Grab a timer and start with short sessions of 10 to 15 minutes. After a few drawings, increase the time to 20 minutes, then 30 minutes. Remember to have fun!

- Draw your parents while they cook.

- Have a sibling or friend pose in a Halloween costume and create a fantasy scene.

- Use a mirror and do a self-portrait.

- Have a friend pose as an explorer and draw them in a prehistoric world.

- Set up a scene with dolls and action figures, and light them.

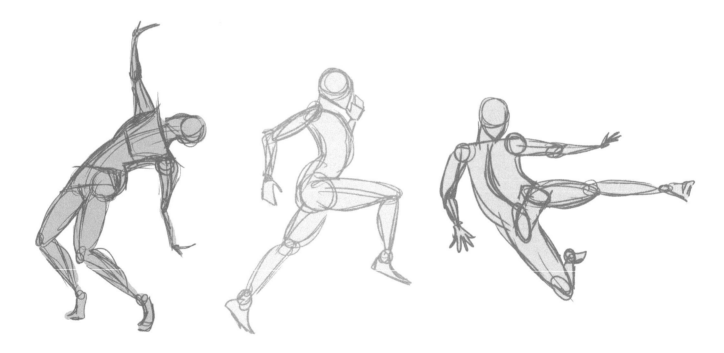

Out in the World

Let's draw outdoors! Take your parents to local parks, cafés, and festivals and sketch people going about their day. This exercise might be initially challenging because people aren't posing for you, but, again, don't stress about being perfect.

Work fast and loose in light pencil to capture your subject. You can do many sketches and add final lines and color later. If you draw someone who's sitting, drinking coffee, or reading, you'll probably have more time to sketch them. If you pick someone playing a sport, they might move too fast.

With your parents, try to visit your local park and find a picnic table to set up your workspace. Look for someone who may be reading or playing games on their phone. Find someone sitting because someone standing could move away at any minute.

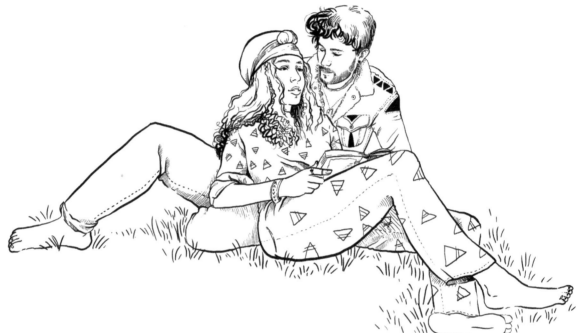

1. Begin by drawing a quick stick figure in light pencil.

2. Add basic shapes to fill out the figure. Try adding a bit of setting in light pencil, too.

3. Sketch some details lightly, such as clothing, facial features, and hair. You can finish this sketch at home or continue to a final drawing if the person doesn't move from their pose.

4. With a marker or pen that doesn't smear, start drawing overall outlines of the figure, clothing, and some scenery.

5. Finish with finer line details, such as shading and textures. Add color if you have the time and supplies.

Practice

- When you go to a coffee shop or restaurant, sketch someone who's sitting. Once you finish, draw someone else in the café on the same piece of paper. Keep going until you have a whole scene.

- Visit the zoo and sketch people watching the animals. Try drawing similarities between the movements or expressions of the animals and those of the people observing them.

- Visit a museum and take inspiration from the art. You can find a drawing or painting you like and draw someone in that style.

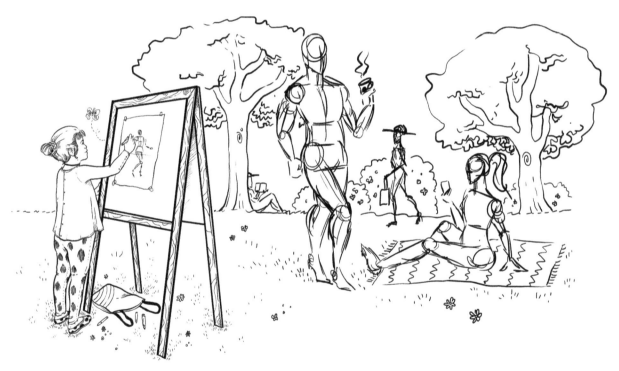

TIP:

I keep a tote bag packed and ready to go. In it are pencils, an eraser, a sharpener, markers, a sketchbook (that can be used for watercolor, ink, and markers), and sometimes a watercolor palette with an Aqua Pen. Aqua Pens are paintbrushes filled with water, so you don't need a cup when using them. Try making your own bag of supplies.

Creating a Finished Illustration

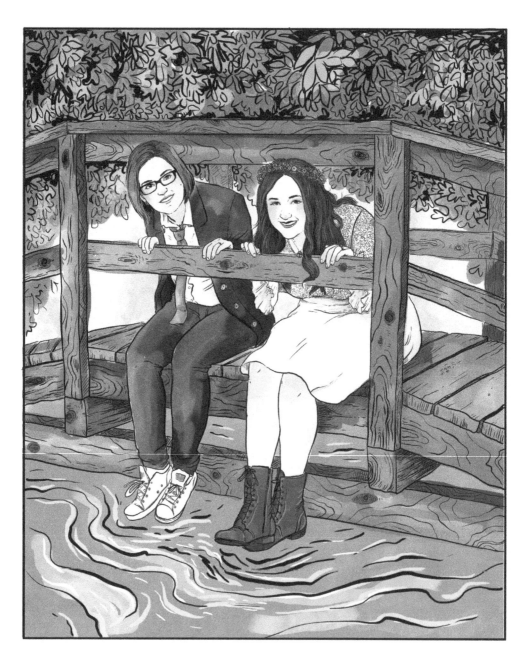

Let's learn about creating a finished illustration from beginning to end. First, gather some supplies.

- Paper made for mixed media

- Pencil

- Eraser

- Ink: fine-line Sharpie, Pentel pocket brush, Micron pens, or Pentel Hybrid Technica in nib sizes 06 and 03 (for details)

- Colored pencils, if you're worried about smudging or bleeding

When creating a piece of art, I pick my reference from online or my own photograph. Then I lightly sketch everything in pencil, erasing unnecessary lines afterward.
 If I'm using wet media (like watercolors), I color first and then ink my final drawing.
 If I'm using dry media, I'll ink and *then* color.

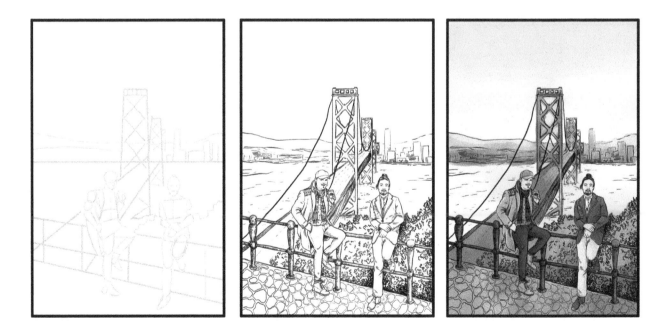

Come up with a story, then the characters and the setting. In this example, kids are enjoying a snow day.

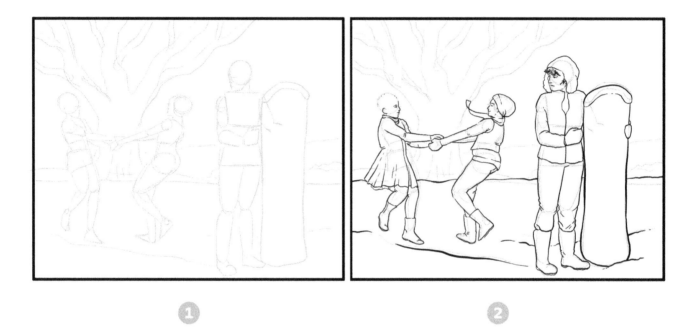

1

2

1 Start with a light pencil sketch of each figure, from the stick skeleton to the basic shapes.

2 Add the main outline in your thickest marker, getting the most important bits, such as the shape of their clothes and the sled.

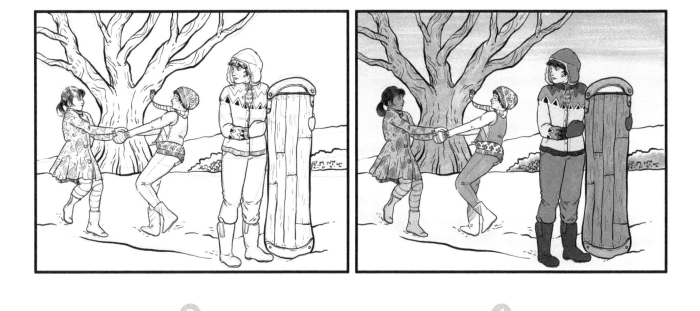

3 Finish the drawing by adding smaller details in a finer ink pen. This picture is going to be colored, so shade in the color step rather than **stipple** or **crosshatch**.

4 Erase the sketch lines. Use colored pencils to shade lightly, then slowly build up color by applying more pressure to make shadows.

Now let's use watercolor to illustrate kids picking flowers in a field. This picture has a triangular composition.

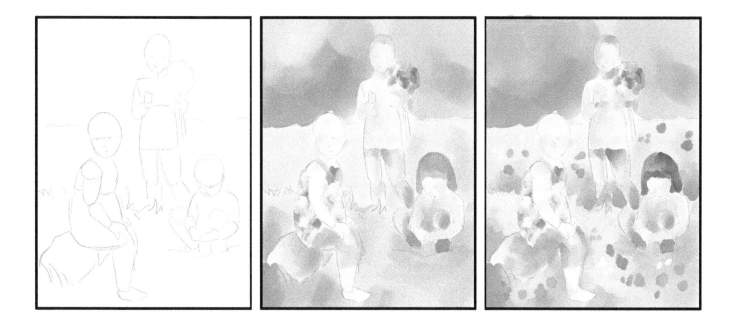

1. Make a very light sketch using only a few simple lines, because once watercolor is on top, you won't be able to erase the lines. Draw basic shapes to create the figures, then erase the lines inside these shapes once you have your full form.

2. Add color. Start out with light washes of mostly water and a little watercolor.

3. Slowly build value with more paint. (With watercolor, less is more.) Let the picture dry.

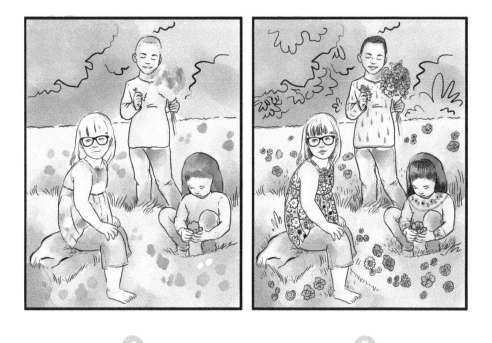

4 Once it's dry, draw the final outline in pen or marker.

5 Add details. Then use colored pencils or colored marker to add pops of color on the lips, some flowers, and wherever else you feel could use more!

FURTHER READING

Learn more about figure drawing and get inspiration from some of my favorite books:

Figure Drawing for All It's Worth and *Drawing the Heads and Hands* by Andrew Loomis. The second one is a classic. My grandfather used it in high school!

Beginning Drawing Atelier by Juliette Aristides. This book presents relatively advanced lessons on drawing and shading. Each chapter tackles the basics of classical drawing.

Urban Watercolor Sketching by Felix Scheinberger. This book is filled with fun, great art and teaches you how to sketch fast and outside the studio.

The Fantasy Illustrator's Technique Book by Gary A. Lippincott. If you love fantasy like me and want to do more of that next, this book is fantastic!

Portrait Painting Atelier: Old Master Techniques and Contemporary Applications by Suzanne Brooker. Did you like drawing faces while doing the activities? Try this book to focus on drawing portraits and to learn more about using paint.

Imagine a Forest by Dinara Mirtalipova. If you enjoyed working on basic shapes or drawing patterns, this book is a great introduction to drawing in a less anatomical, more folk-art style.

Making an Impression by Geninne Zlatkis. If you love art and want to try a new medium, this book is filled with great how-to projects, such as how to make your own stamps.

Picture This: How Pictures Work by Molly Bang. This in-depth technical book explains what makes a good picture. It explores subjects such as composition, graphic design, and evoking emotion with linework.

Draw Your Day: An Inspiring Guide to Keeping a Sketch Journal by Samantha Dion Baker. I've been drawing every single day since I was a kid, so I have an attic full of sketchbooks. The key to becoming an artist is to keep practicing, and this book has exercises that keep you going when you get stuck.

INDEX

ABOUT THE AUTHOR

Angela Rizza graduated from the Fashion Institute of Technology in New York City in 2011 and since then has been creating artwork in Mahopac, New York. Her work is inspired by the wildlife around her home and her favorite childhood stories. She enjoys teaching art and creating activity books that help others learn and use their imagination.